STAMP-A-GREETING™

Judy Ritchie, Kate Schmidt,
and Jamie Kilmartin
Stamp designs by Judy Pelikan

HUGH LAUTER LEVIN ASSOCIATES, INC.

GETTING STARTED

Creating beautiful greeting cards, stationery, gifts, and packaging is well within the range of everyone's abilities when you create with rubber stamps. You do not have to be an artist to express your creative talents. Rubber stamping is fun, easy, and rewarding, and offers a wide range of outlets for creative expression. It is also a perfect activity to fit into today's busy lifestyles. For young and old alike, stamping can be enjoyed alone or in groups. All you need are a few stamps, an ink pad, papers, markers, a few accessories, and you're ready to start.

The *Stamp-A-Greeting*™ kit contains 27 art rubber stamps to create greetings for every occasion; a black ink pad; red, blue, and black brush markers; pink, blue, purple, yellow, brown, and green colored pencils; and crystal glitter glue to enhance your designs. Also included in the kit are 12 blank greeting cards with envelopes and 12 place cards to get you started. This kit contains everything you need to shower your friends with greeting cards, wrapping paper and gift tags, bookmarks, place cards, and invitations. Just spend a few minutes learning the basics of stamping. Once you have read the first few sections of this guide you will be able to create artwork that will impress your family and friends as well as professional stampers. We all love to receive handmade cards and gifts, and working with rubber stamps gives you the opportunity to create professional-looking works of art created just for the recipient.

Every stamper has his or her own way to approach a project and his or her own way to stamp. We offer suggestions here on how to stamp, but you don't have to do it our way if you are comfortable doing it another way. For those of you already familiar with the basics of stamping you might want to concentrate on the *Stamp-A-Greeting*™ Special Projects. All of the stamps in the *Stamp-A-Greeting*™ kit have been specially designed to work together, as well as to complement the rest of your stamp collection.

Stamps are magically versatile tools. By combining them in different ways you can achieve many effects. Look in the *Stamp-A-Greeting*™ Special Projects section of this book to see how we have combined some of the stamps.

Using the stamps in different ways and in different combinations not only provides you with more images to work with, but also helps you to stretch your imagination and tap your creativity. Learn how to look at your stamp collection with a fresh eye by analyzing each element of the stamp design. We have used parts of stamps separately as well as together.

Notice, for example, how we have used the sun stamp in different combinations: for Project Number 3 it is used whole, as a sun; in Project Number 16 we have separated the sun's rays from its center and used the individual elements as strong graphic devices; in Project Number 83 the sun becomes a garden of flowers. The ivy can be used as a single piece of ivy, as a corner, or as a full frame. You can find many others on your own.

We hope this book inspires you to express yourself and use your stamps creatively. You have everything you need in this kit to make literally hundreds of projects. In the *Stamp-A-Greeting*™ Special Projects section we show you how to make 100 projects, but we are sure that you could come up with another 100. Don't be limited by what you have; explore every possibility.

Surprise and delight your family and friends with clever, original cards and presents handstamped by you.

Be creative and have fun!

We have provided you with materials to make dozens of interesting projects,

but don't hesitate to extend that number by using these stamps in combination with other inks, markers, paper, glue, glitter, or even with other stamps that you already have.

*M*any stampers prefer working with wood-mounted rubber stamps. To mount the stamps from this kit on wood see page 55.

*U*se your creativity to add hand-drawn elements to your designs. It is easy to copy the confetti on the "Congratulations" stamp and to enlarge it free-hand, or add an apostrophe to the "Valentines" stamp to say "Happy Valentine's Day." Use the alphabet on pages 61-62 to personalize your greetings. The dots on Project Number 61 were stamped with a new pencil eraser; we stamped a group of flowers and then added dots with a pen to tie the whole arrangement together.

THE STAMP-A-GREETING™ KIT

*T*he first step in using the *Stamp-A-Greeting™* kit is to break apart, along the perforations, the stamps included in

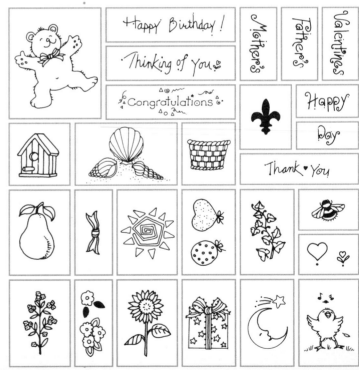

the kit. Once the self-sticking stamp labels (also included in this kit) are placed on the appropriate stamps you can quickly identify the stamps.

To prepare the labels, peel away the stamp images from the sticker paper that was sitting on top of the stamps in the kit. Position and stick the cut-out label onto the top of the appropriate stamp, making sure the sticker image is oriented in the same direction as the stamp image. If you wish to protect the labels, cover each with heavy transparent packing tape or clear contact paper. Remember to trim the excess tape flush with the stamp block.

It is best to store your stamps rubber die-side down, out of direct sunlight, and away from heat and dust. Sunlight and excess heat can harden and dry out the rubber, making the stamps unusable.

Prepare a work area before you begin to stamp. You can achieve the best results and sharpest images by working on a cushioned surface. A pad of newsprint, a computer mouse pad, or a magazine will all work fine. The newsprint pad is especially helpful because it can function simultaneously as a cushion and scrap paper.

Tip: Always open your cards and lay them flat so you have an even surface on which to stamp. If you try to stamp with the card folded, the ink will not adhere properly on the double thickness. When you stamp on envelopes or paper bags, slip a piece of cardboard inside, between the two surfaces, for the best stamping results.

The kind of image on a stamp dictates how to stamp to obtain the whole design printed evenly. For example, large stamps or stamps with large solid areas require more ink and pressure than finely detailed stamps. Apply pressure evenly as you stamp directly down on the paper. For large images, hold the stamp with one hand while pressing evenly on the top of the stamp with the other. To avoid blurring the image be careful not to rock or wiggle the stamp. To avoid smudging, wait until a print is dry before stamping next to it.

Because each stamp has its own peculiarities (some stampers might even say

"personality"), it is important to make test prints on scrap paper before stamping on your good paper. You can then adjust specifics to accommodate the peculiarities of the stamps, the ink, or the paper.

*T*he ink pad included in this kit contains a water-based dye ink for use on glossy or matte paper. The pad can be re-inked when it runs dry. Store your ink pad upside down to bring the ink to the surface. This way your pad will always be ready to use. Some stampers store their ink pads in the refrigerator to retard evaporation. The water-based

brush markers in this kit contain the same kind of water-based ink as the ink pad and therefore are usable on all papers. Remember to cap your markers when they are not in use to prevent them from drying out.

*A*n essential stamping tool is a cleaning plate ready to clean the ink off each stamp as you finish with it. To prepare a cleaning plate moisten a paper towel, sponge, or small rag with warm water, gently wring it out, and place it on a plate.

*B*e sure to clean the ink off of each stamp before changing colors, or when you are finished stamping. To clean the stamp, gently tap it several times image side down on scrap paper to remove as much ink as possible. Then tap the stamp (image side down) onto the cleaning plate and, finally, onto a clean, dry paper towel to remove excess moisture.

*N*ever use harsh cleaners or alcohol-based solvents to clean your stamps. They could

Hold the stamp firmly with one hand and press down on the stamp rotating your finger evenly across the back of the stamp.

leave a film on the stamp or dry out the rubber. If the ink seems particularly stubborn, try scrubbing the rubber with an old toothbrush dipped in water. To remove ink from your hands, try baby wipes or soap and water.

*Th*e note cards and place cards included with this kit have a matte finish. Note how the ink from both the ink pad and the markers works with this paper. Experiment with other papers to find what you like best. Use the papers in this kit as a reference when purchasing additional papers for stamping.

*W*e have provided markers in the *Stamp-A-Greeting*™ kit, so you do not have to ink every bit of every stamp. Sometimes you will want to use only a part of a stamp. As you will see in our project section these 27 stamps become many more if you use them creatively. You don't have to use all of the shells together, for example; you could use one or two. You don't have to use the moon with the star every time; you can use one or the other. You could use the bird without the notes; you could isolate the confetti on the "Congratulations" stamp and stamp it all over a card to create a background. The "Valentines" stamp can be used as it is to make a special bag to hold your child's valentines, or without the "s" it can be part of a "Be my Valentine" greeting, or with an apostrophe added, part of a "Happy Valentine's Day" greeting. There are many options which will be fun to use as you gain confidence as a stamper.

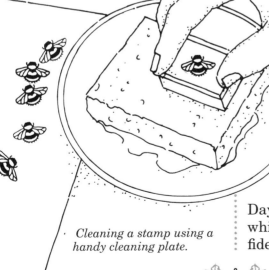

Cleaning a stamp using a handy cleaning plate.

\mathcal{D}on't overlook the colored pencils provided in the *Stamp-A-Greeting*™ kit. The subtle shading and soft color achieved with these pencils can add another level of sophistication to your stamped art.

SUPPLIES YOU'LL NEED

\mathcal{I}n addition to the items found in the *Stamp-A-Greeting*™ kit, assemble the following items before you start your projects:

❖ scissors

❖ pad of paper, or some other cushioning surface

❖ X-Acto knife, or mat knife

❖ scrap paper

❖ card stock or index cards

❖ sticky notes or thin paper for masking

❖ wet paper towels on a plate (a cleaning plate)

❖ glue, double-sided cellophane tape

❖ double-sided foam tape

❖ uncoated matte finish gift wrap, and plain tissue paper

❖ uncoated matte finish lunch bags

❖ ruler

❖ hole punch

BASIC
TECHNIQUES

INKING WITH AN INK PAD

*T*ap the stamp gently a few times onto the ink pad and then check to make sure the whole image is covered with ink. If you are too forceful when tapping the stamp on the ink pad, you may get ink on the rubber area surrounding the image which could leave unwanted stray marks on your paper. Sometimes, especially if the stamp is larger than the ink pad, you may want to reverse the technique and gently tap the ink pad onto the stamp surface.

*T*o achieve a lighter or more subtle shade of ink, stamp first on scrap paper and then, without re-inking, stamp the image on your "good" paper. This technique makes an interesting background design to appear under other stamped images or attractive stationery with a subtle overall pattern.

*P*ractice inking your stamps and stamping a few impressions on scrap paper or an extra sheet of good paper a few times to learn the idio-syncrasies of each stamp. Some of the images need more ink than others; some need less.

*A*lways keep your stamp pad closed when it is not in use; otherwise it will dry out. And remember to store your ink pad upside down when it is not in use so the ink always stays on the surface.

Use an ink pad to stamp a single image in one color.

INKING WITH WATER-BASED MARKERS

*A*n alternative to using an ink pad, and our favorite way to work, is with water-based brush markers. Hold the stamp in one hand with the rubber die facing up, and color or paint directly onto the raised stamped image using one or more colored markers. Work quickly to keep the ink from drying. If necessary, breathe gently on the stamp (with an open-mouthed "HAH") to add moisture to the ink just before stamping. Depending on the paper you are using, you may be able to get a second impression without re-inking the stamp by simply breathing on the stamp once again. You will soon be able to judge when you need to re-ink a stamp. Just practice with each stamp a few times, and it will all become second nature to you.

USING BRUSH MARKERS ALLOWS YOU TO:

❖ Stamp in a wide range of colors that are not readily available in ink pads.

❖ Stamp a multicolored image by apply-ing different colors to various parts of the stamp.

❖ Stamp a portion of an image.

*W*hen inking the stamp, be sure to brush over the entire image you wish to print with the side of the marker. When you want to use more than one color, always ink the lighter color before the darker one to avoid getting darker ink on the light marker. If you find that you have excess ink on the paper after stamping, simply turn your finished artwork over and blot it lightly on a piece of scrap paper.

*B*e sure that the markers you use on your stamps are water-based. Permanent ink could harm the rubber on the stamp.

Color different parts of the stamp with different color inks.

PLANNING YOUR LAYOUT

Some artwork looks so right you might think it just happened that way, the way the cliffs meet the sea, or a wildflower pops out of the earth at just the right spot on a summer morning. But, of course, we have to plan our designs. And, frankly, this is probably the most exciting part of creating a project. Now is the time to decide what you are saying with your artwork. What do you want the recipient of your card to

feel, for instance? We all know that bright colors are cheerful, soft pastels soothing, and dark colors elicit a more somber or dignified response. But did you realize that where you place an image on a page has as much effect on the viewer as the colors you choose?

The visual placement of objects on a card or package can be unpredictable and exciting, predictable and soothing, or reliable. Just as the tilt of a head or a hand can be an inviting or a dismissive gesture, so, too, can the orientation of a figure in your artwork. Look at the children's birthday party page in our Special

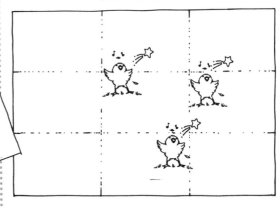

Dividing your space into thirds horizontally and vertically can produce interesting layouts.

Projects section to see the many ways we used the bear stamp. It makes you smile. It might even make you feel like celebrating! Notice how the balloons appear to be flying free when their string is wavy and in place when the string is taut.

This is all a way of saying that you can direct the effect of your work by being aware of certain basic design concepts.

Placing a design element (one of our stamps) right in the middle of a card might sometimes be effective; but not always. Look at Old Master paintings, for instance. The focal point is not usually dead center.

One trick that we use constantly in planning our layouts is to divide the space into thirds horizontally and vertically (make a tic-tac-toe board). And then we move the stamp images around within the quadrants. The most interesting visual points are near the intersecting lines, so arrange your design around one or more of those focal points, filling in the background as needed. Please don't feel compelled to fill up all the white space on

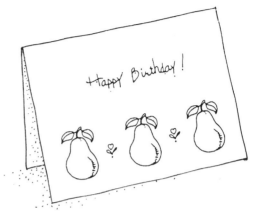

This card, with three impressions of the pear stamp, offers a strong statement.

your card. Space is as important a design element as any of the stamp images.

On a practical note, be sure to plan your layout on scrap paper. This is very helpful when designing a card like our Project Number 13, for example. You want the flowers to look like a garden when the card is closed and like a row of flowers when the card is open. We decided on the size of the card after stamping the flowers on scrap paper. You might find it helpful to stamp the images on paper; then cut them out. These cut-outs are easy to move around as you finalize your design.

When creating a scene with stamps that are not all of the same scale you may want the larger elements in the foreground with the smaller elements in the background.

THE STAMP POSITIONER

One of our favorite tools is a stamp positioner. It assists in placing a stamped image precisely where you want it. The stamp positioner has helped us many times. Sometimes, no matter how careful we have been, an image is not stamped cleanly or clearly, and rather than throw away the whole project, we used the stamp positioner to guide the placement of a new image stamped in exactly the same spot as the defective one, right over the defective image.

The positioner is made from two pieces of clear lucite 1/2 inch thick joined at a right angle. Use it with tracing paper.

First, mark the corner edges of a piece of tracing paper that has been cut at a right angle. (We actually just run the edge of a color marker along the edges.)

This will allow you to see that the paper is sitting snugly in the corner of the positioner and has not slipped under it.

Stamp the image onto the tracing paper being careful to slide the stamp down along two sides of the stamp positioner. Move the tracing paper image around to see where you want it stamped on your finished project. Bring the positioner to the paper, again making sure it fits snugly in the corner touching both sides of the positioner. Remove the tracing paper and stamp as you did when you stamped on the tracing paper. Save the tracing paper to repeat this process whenever you use that particular stamp.

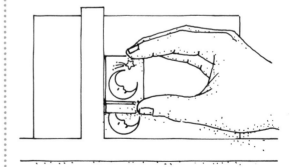

Place the stamp in the angle of the stamp positioner to align images on the page.

\mathcal{A} stamp positioner is not essential, but it will save you money by preventing stamping errors on good paper.

\mathcal{W}hen planning your project, test the colors of your inks, pencils, and markers to see how they will work together. Test colors on the same kind of paper you'll be using for your finished project since paper surfaces vary.

ADDING COLOR

\mathcal{W}hen you are using stamps that are primarily an outline, you can achieve stunning results by coloring in the image after stamping it. See our floral wrapping paper or sun gift tag as examples, both of which are outline drawings, as opposed to the fleur-de-lis, which is a solid design.

\mathcal{S}tamp the outline image with a dark ink on any kind of paper— glossy or matte— if you are going to color with markers. If you are going to use colored pencils, stamp on matte or nonglossy paper. When the ink is dry, color in the image just as you would in a coloring book. Use fine line markers to create bright colors, and colored pencils to achieve a softer look.

\mathcal{Y}ou can achieve wonderful gradations of color with colored pencils. The harder you press, the darker the color will appear. Colored pencils often look better against a soft outline, which you can create by using the technique outlined earlier: that is, press the stamp on the ink pad, tap it once lightly on scrap paper, and then stamp the image onto your paper. If you are using black ink, this method will give you a gray outline.

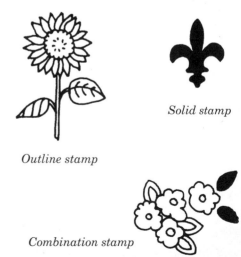

Solid stamp

Outline stamp

Combination stamp

SPARKLE

*A*dd excitement, sophistication, and sparkle to your projects with glitter-filled glue. Apply the glitter glue to accentuate specific areas of your stamped design. The crystal glitter glue in our *Stamp-A-Greeting*™ kit is very easy to use. Simply tip the container upside down and gently squeeze the bottle as you drag the tip along the line, or dab lightly on the spot you wish to highlight. Allow the glue to dry for two to four hours.

*G*litter glue is great for filling in or outlining stamped images, and adding dimension to your designs. Put glitter glue on one side of your balloons to reflect the light and give the balloons a rounded appearance.

*I*f our glitter glue is not glittery enough for you, sprinkle additional dry glitter on the image after applying the glitter glue. You can add glitter of different colors to the crystal glitter glue. Gold glitter gives a very rich effect.

*T*he application of glitter should be the last step in the execution of your project. Never put glue directly on the rubber stamp die because it will ruin the rubber. If your stamp should pick up some glitter, remove it by tapping the sticky side of a piece of transparent tape on the rubber die.

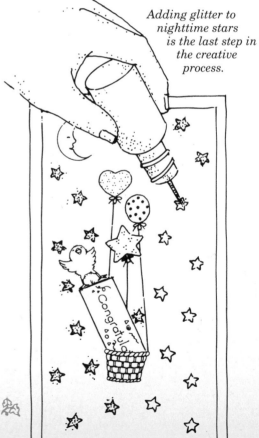

Adding glitter to nighttime stars is the last step in the creative process.

REPEATED IMAGES

A border of little heart-flowers complemented by more flowers and a handwritten message.

One stamp can go a long way when it is used to make patterns, borders, or clusters. Use the same color ink and stamp across the bottom, up both sides, or all around the edges of a card to create a pattern or border. Try alternating colors for variety. Or stamp one design and repeat all over the card to create a background pattern or texture. If you change the angle of the stamp as you work you do not have to worry about aligning the images perfectly.

It is important to consider the size of the stamps you use together when they are borders or patterns. Stamps must work together visually. For example, in Project Number 76 the heart and the flower used are the same size and complement the bold hand-drawn border. If the stamps are not of similar size, the effect could be confusing, and certainly not as striking.

To ensure equal spacing when you wish to repeat several of the same image in a row, stamp the first image in the middle, then on the ends, and finally fill in the middle. A stamp positioner, ruler, or firm

Alternating hearts and flowers create this repeat.

cardboard box with a straight edge helps to line up the stamps.

*W*hen stamping images over a large area (wrapping paper, for instance) one concern is that the images be spaced evenly. Use a grid to help you align and space the images. If you don't have a translucent cutting mat with a grid, prepare your own by drawing lines with a

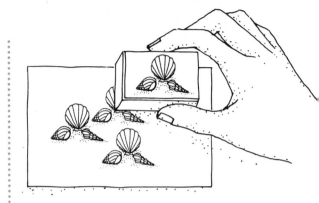

Stamped shells positioned to create depth.

permanent marker on white paper or clear acetate, or foam core. (Foam core works well because you can thumbtack your paper to it.) Lay your project over the grid and proceed with your stamping.

*T*o create the illusion of depth when repeating images, try stamping an image in the foreground first and then, without re-inking, stamp slightly higher on the page so that the images overlap.

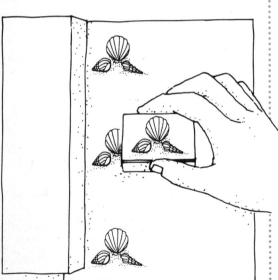

A straight edge helps when aligning multiple images.

MASKS

\mathcal{C}reating a scene with rubber stamps is fun and easy to do. In fact, it is much less complicated than it looks. To create the illusion of depth in your scene, with one image appearing to be behind the other, use a simple masking technique. Begin by stamping on the paper the image that you want to appear closest to the viewer (in the foreground).

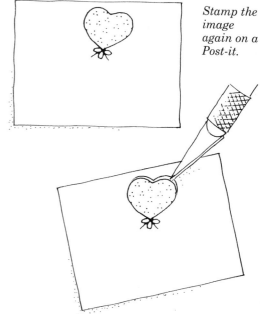

Stamp the image again on a Post-it.

The stamped cut-out mask.

\mathcal{N}ext, stamp that same image onto a piece of thin scrap paper, or a sticky note (a trade name for these gummed labels is Post-it). The sticky part of the note should be under your impression. If you don't have a sticky note handy, use scrap paper, but leave a "handle" to hold, as in the drawing here. Cut out the image carefully, staying just inside the outline. This is your mask. Place the mask

Preparing to stamp over the mask.

Once the scene is completed, remove the mask.

over the already-stamped image to protect it. Now, stamp the second image (the one that you want to appear "behind" the first one) partly overlapping the first (masked) image.

*Y*ou may have to increase the pressure applied on this stamp to compensate for the thickness of the mask and to prevent a gap between the two images. Remove the mask. You can repeat this process over and over again on the same card to accentuate the illusion of depth. By using this masking technique you will be able to turn a single balloon stamp into a large bunch of balloons to celebrate an event.

*O*nce you have gone to the trouble to create a scene with masks you should certainly save the masks for future use. Maybe you plan to make ten cards with this design, or you might be using the stamp in a different scene. The mask can be used whenever you wish to use the stamp in combination with any other stamps.

Store the masks you wish to keep in individual envelopes, and be sure to mark the outside of each envelope by stamping the image on it. Or you might prefer to keep the envelopes in an acrylic pocket or page in a notebook.

Using this same masking technique, you can cover a section of paper you want to keep empty and stamp the fully-inked image partially overlapping the mask. By using masks, the flowers with their sponged backgrounds stand out from the rest of the card.

Using a mask top and bottom helps to create a free-floating garden of flowers.

When you want to keep the back side of a folded card free of stamped images and you want to stamp right up to the folded edge, you could use a piece of paper to mask the area. Open the card and place it on your work surface with the inside facing down. Cover the back side of the card with a piece of paper aligned at the fold, and stamp the front of the card. Some of the images can spill over onto the mask. Remove the mask and you will have a straight, clean edge.

To design a card with a flower in a basket, first stamp the basket, make a mask of the basket, and align the mask with the stamped image. Stamp the flower partially overlapping the mask. Remove the mask and the flower appears to be growing out of the basket.

FRAMES AND BORDERS

*F*rames and borders are attractive design elements that add an interesting dimension to your projects especially when you have small stamps. There are many, many ways to create a frame or a border. For example, you could cut a shape out of paper and place it on top of your card stock. This is a mask just as the masks discussed in the previous sec-

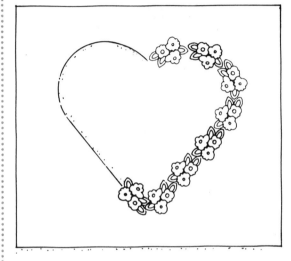

Repeating the flower stamp creates an appealing heart frame.

Using a die-cut mask to create a heart of flowers.

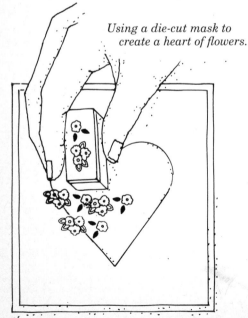

tion, but you are going to stamp around the outside of the masked shape, overlapping the mask itself. When the mask is removed you will have a wonderful, clean-edged framed space. You can create any size and shape frame by changing the size and shape of the mask. You probably have lots of ordinary things around the house that could be used to design masks. Index or playing cards work well. Or try tracing around cookie

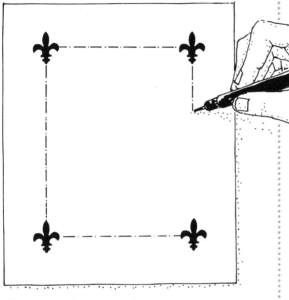

Connecting four corner images to create a frame.

the center. Stamp the image inside the opening with some of the image falling on the mask that will be removed. When you remove the mortise mask, the shape will contain the stamped images, but the border of your card will be empty.

*A*nother way to create a frame is to lightly pencil in a shape on a card and then stamp all along the penciled line to create the shape you've drawn. After stamping, erase any pencil lines that show. We used this technique in Project Number 37 when we used the flower stamp to create a floral heart wreath.

*Y*et another way to make a frame for your card is to stamp a small image in each of the four corners and then draw lines to connect each image, as in Project Number 1. A simple border created by adding dots or dashes can also be effective.

cutters or small containers, or draw a freehand shape to create unusual masks. The largest heart in Project Number 36 was designed using this technique.

*T*o create a focal point and keep the frame of your card free of stamped images, prepare a "mortise mask"; a piece of paper the same size as your card with a shape or design cut out of

*T*o hand draw a frame like the one on Project Number 76, draw a line 1/2 inch in from all four sides of the card. Draw

another frame 1/4 inch inside the first one. Then, between the two frames draw an even number of lines on each side to get an uneven number of boxes. Color in every other box, starting at all four corners.

*A*n easy way to draw a straight line parallel to the edge of your card is to lay your card in the middle of a large sheet of ruled notebook paper, with the card edge aligned with one of the rules on the paper. Using another rule of the

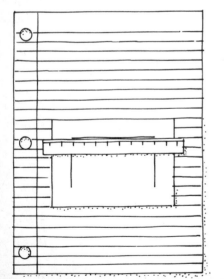

Ruled paper used as guide for creating parallel lines.

paper as a guide for your ruler, draw a straight line across the card. If you want a frame on all four sides simply rotate the card and repeat. It might be best to draw the lines lightly in pencil so that any extra marks can be erased.

*W*e have included on pages 61-62 of this book a special *Stamp-A-Greeting*™ alphabet. Now that you know how to create frames and borders, you might want to experiment with a valentine like this drawing. Create a border and a heart frame and then write the valentine message—"You are my Valentine"—using the *Stamp-A-Greeting*™ alphabet and the "Valentines" stamp. Don't ink the "s" in "Valentines."

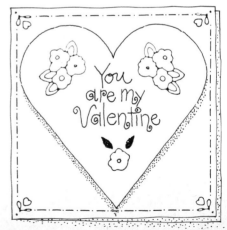

3-D EFFECTS AND SHADOWS

*A*dd dimension to your work for a more realistic or whimsical effect. As you've learned, masking an image and stamping another image "behind" it gives the illusion of depth. This is only one of many techniques to achieve a three-dimensional look.

*W*hen you want an image to literally stand out from the others on the page, stamp it onto your card, then re-ink and stamp the image again on another sheet of card stock.

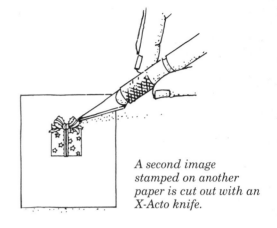

A second image stamped on another paper is cut out with an X-Acto knife.

Stamping the image on a card. This image will become three-dimensional.

*C*ut out the second image and affix it to the first image you stamped on the card with a small piece of double-sided foam tape (available at stationery and office supply stores). Use more layers of tape to achieve various heights in your overall design.

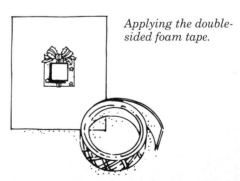

Applying the double-sided foam tape.

27

A three-dimensional birthday present.

*F*or another three-dimensional look, you can stamp an entire image on a card, and then, using an X-Acto knife, cut out part of the image and bend the cut edges forward. This works best with a symmetrical design. For example, stamp the teddy bear included in the kit and cut around the outside of his arms (being careful to leave them attached to his body). Gently fold his arms forward and he will reach out for a hug.

*A*nother way to create depth in your design is to stamp an image in one color, and then stamp the same image in a second color about 1/16 of an inch away (usually up and off to one side). Don't forget to clean the stamp between inkings.

*T*he addition of a shadow adds dimension to your artwork. You can create a shadow by drawing a bold line along the outside edge of an image with markers. Determine where the light is coming from. This light source should affect each object in your design in the same way. For example, imagine the light source in the top right-hand corner of your paper. You would then add the shadow below and to the left of each image by drawing a line with a light gray, blue, or even lavender marker along the outer edge.

The bows are cut and bent forward for a 3-D effect.

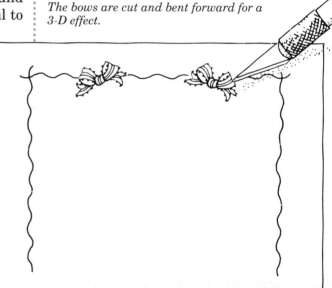

POP-UPS AND POP-OUTS

*P*op-ups and pop-outs do just that. An image appears to jump out at you as you open the card, or it extends beyond a folded edge of a card. Cards made using the following techniques are simple to execute and are guaranteed to surprise and please.

*S*elect a stamp that will fit within the dimensions of the card you are design-ing. In our kit the teddy bear and birds were designed as perfect pop-up images to be used with the cards in the kit. Stamp the image that will pop up from your card onto a separate card or index stock. Color it in as you wish, and then carefully cut it out using a scissors or X-Acto knife. This cut-out image must be attached to a base to allow it to pop up when the card is opened.

*T*o make the pop-up base, cut out a strip of card stock narrower than the pop-up image. To make our bear pop up in the example we cut a base strip 4 inches long and 1/2 inch wide. Crease and fold the strip at 1-inch increments. Open your card so that it lies flat, with the inside facing up. Decide at what horizontal point you want to place the pop-up image. Glue section 1 to the bottom of the card at that point, and section 4 to the top of the card so that the two ends of the strip meet at the fold of the card. Gently close the card to confirm that the measurements are accurate. Adjust the position as necessary. Attach the cut-out bear to side 2. The image lies flat when the card is closed and will automatically pop up when the card is opened.

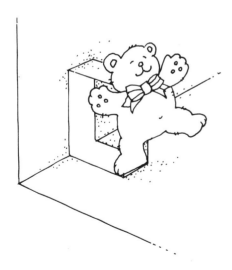

The bear pops up from the fold of the card.

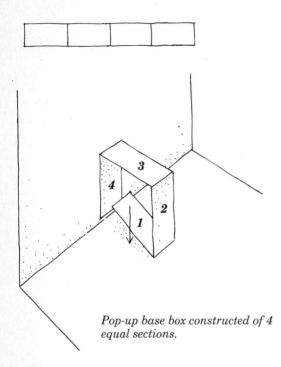

Pop-up base box constructed of 4 equal sections.

In our kit, the bear is about 1 1/2 inches high and segment 1 of the base is 1 inch high. This total of 2 1/2 inches fits comfortably within the 4 1/4-inch height of our cards. If the pop-up image is too large it will protrude beyond the edges of the folded card and look haphazard.

*H*ere is another simple way to construct a base for the pop-up element from the card itself. With a card closed, measure along the fold, 2 inches from each side. At those two points, draw a 1-inch-long parallel line down from the fold. These lines must be identical in length. Cut on the lines, fold the cut middle section over front of the card and press it down to crease. Turn the card

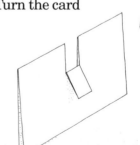

*T*his is one of the simplest ways to create a pop-up card. As you gain more experience creating pop-up cards you can experiment with different size bases.

*W*hen selecting other pop-up images, it is important that the stamped image plus the length of section 1 of the base measure less than the height of the card.

A pop-up platform base is created from the card itself.

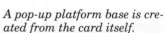

over, fold the same section in the opposite direction, toward the back of the card. Open the card and press the middle, cut, piece up from behind to form a box shape or platform on which to place your pop-up image. It is sometimes helpful to work from the front using a pencil to pull the base forward. Close the card. The base will fold forward inside the card. Stamp the inside of the card and attach the image to the pop-up base. Carefully apply a thin layer of glue around the outside edges of the card. Open a second card and place the cut card inside the uncut card, matching the center folds. Press the two cards together; close the card gently, pulling the pop-up base toward you.

*Y*ou need not be limited to one platform or base. You can make several—as many as you wish, a whole town's worth; and even pile one platform on top of another as long as you remember to always cut on a fold. And always experiment on scrap paper first.

*Y*ou can learn about other methods for creating pop-ups by consulting any of the many books on the subject that are available in the arts and crafts sections of most bookstores and libraries.

Pop-out base box constructed of 5 equal sections.

A pop-out card is similar to a pop-up, but the image can pop out from anywhere on your card. Unlike a pop-up image, a pop-out image does not have to be placed at the fold. Stamp the image that will pop out from the card onto card or index stock (sturdy paper). Color the image and cut it out. To construct a pop-out card, cut out a base similar to the one for pop-ups but with five equal parts instead of four. Glue section 1 to section 5 to form a square box. Next, attach the already-glued-together sections 1 and 5 to the card anywhere in your design. Glue the cut-out image to section 3. The pop-out image will lie flat when the card is closed. Once the card is opened, pop

out the image by simply lifting it up.

To make a card or place card with an image that extends or pops up above the fold line, lay the paper or card flat and stamp part of the image, as much as half, above the fold line. Using an X-Acto knife, cut around the part of the stamped image above the line. Score at the fold line but do not score through the image. Fold the card, or place card, and the image will pop up.

Cut out the portion of the image that is to extend beyond the fold.

Part of the stamped image is above the fold line of the card.

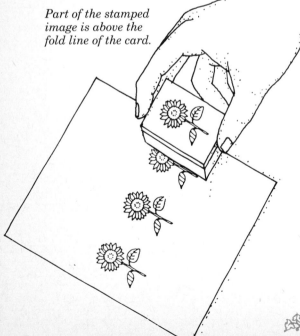

Fold the card, and the image pops up above the fold line.

THE ILLUSION OF MOTION

If you want to make an image appear to be moving, first ink the stamp and stamp it on the paper. Lift the stamp off the paper and, without re-inking it, stamp only the "trailing" portion of the design several times, close together and in the direction from which you wish the image to appear to be coming.

Another way to show movement is to stamp the image and, without re-inking or lifting the stamp, drag it backwards. You could try this with the bird stamp to make him look like he's hopping.

This little bird looks like he's hopping up and down.

A bird moves across the page.

NEW TECHNIQUES AND MATERIALS

MOVING ON

\mathcal{N}ow that you have read the section on the basics of stamping and completed many projects using the *Stamp-A-Greeting*™ kit, you know how easy it is to express yourself with the basic products and instructions for stamping.

\mathcal{Y}ou are ready to move on to more advanced techniques.

\mathcal{Y}our stamped artwork can be embellished with many different design elements using a variety of art materials. This section introduces you to many of those materials and the techniques you need to know to use them. But before starting you might review this suggested list of additional materials, all of which are readily available at rubber stamp stores and many craft and art supply stores across the country. The Great American Stamp Store in Westport, CT, is also a full service source for all your stamping supplies.

- ❖ Pigment ink
- ❖ Embossing powders
- ❖ Embossing pens
- ❖ Heat gun
- ❖ Rainbow ink pads
- ❖ Paper—vellum, rag, watercolor, tissue
- ❖ Ribbon
- ❖ Crack-and-peel (sticker) paper
- ❖ Watercolor pencils and brushes
- ❖ Soft chalks
- ❖ Sponges
- ❖ Brayer
- ❖ Eraser (or reverse-image stamp)
- ❖ Glitter (various colors)
- ❖ Glue stick
- ❖ Fabric paint
- ❖ Foam brushes
- ❖ Acrylic paints (for wood), sand paper
- ❖ Spray sealer for wood
- ❖ Paper cutter, pattern-cutting scissors
- ❖ Embossing markers
- ❖ Metallic paint
- ❖ Fabric inks

PIGMENT INKS

Pigment ink, unlike dye-based ink, is opaque and is available in pads of many different sizes and shapes. This means that the color of your paper will not affect the color of the ink.

Pigment ink is available in a wide range of colors, including many metallic shades like gold, silver, and copper. Pigment ink resists fading and has a balanced pH, which minimizes acid deterioration. Consequently, it is an ideal choice to use in combination with other artwork or photographs. Pigment ink is slow-drying, and requires an absorbent surface. However, if you want to use it to stamp on glossy or coated paper (which is non-absorbent), you must emboss the ink to make it permanent. It is this slow-drying quality that makes pigment ink ideal to use when embossing on any paper.

To ensure an even ink coverage, the best way to ink your stamp with a pigment pad is to hold the stamp in one hand with the rubber image facing up and gently pat the entire stamp with the ink pad, held in the other hand. Hold the stamp at an angle in the light to see if

Inking a stamp with a pigment ink pad.

there are any dry spots. If the stamp does not appear to be entirely wet, tap the stamp with the ink pad again. This method of inking allows you to cover even the largest stamp with a small ink pad.

Be careful not to over-ink your stamp when applying pigment ink. Because this ink is thick, over-inking will fill in the recessed areas of the stamp and make it difficult to get a clear, detailed impression. It might also cause an undesirable shadow if there is ink on the base of the stamp.

RAINBOW INK PADS

*R*ainbow ink pads contain three or more colors or shades of the same color. They are available in both pigment and dye ink. Using rainbow ink pads is a very simple way to add variety to your stamped art.

*T*here are two methods of manufacturing dye rainbow pads. The less expensive pad is created by cutting the felt pad into strips or sections and applying a different color to each section. These pads separate the colors with plastic dividers which must be removed before use. After stamping with such a pad you may be able to see the separations on your finished artwork, especially if you use a design with a lot of solid area. To compensate for the separations, you may want to move the stamp around slightly as you tap it onto the ink pad. This ensures an even coverage of ink over the entire surface of the stamp. Other rainbow pads are made by hand with the application of the ink to the felt. The colors blend well as the inks flow together. Over time the ink on all types of dye-based rainbow pads flows together, mod-

ifying the colors. To slow this process clean your stamp before use and after each impression, and always store the pad flat. Some rainbow pads separate each color when the pad is not being used to prevent the blending of ink. Dye rainbow pads can produce dazzling results, especially on glossy or coated paper. Try using a brayer with rainbow pads to create great backgrounds.

*T*here are also multicolored pigment ink pads that will give results similar to those of the dye-based rainbow pads. Because of the inherent properties of pigment ink the colors will never blend together on the foam pad. Tapping your stamp several times with different areas of the pad will produce a kaleidoscopic effect. If mixing the colors on your stamp has carried one color onto the top of another on the pad, restore your pad to its original color by simply wiping it vertically with a clean, dry paper towel. Both pigment and dye inks are available in bottles so that you can re-ink your pads when they dry out. You can also use these bottled inks to make your own rainbow pads out of an un-inked felt or foam stamp pad.

OTHER INKS

*M*any types of paints and inks can be used to stamp images. We have used both poster and acrylic paint and metallic pens. If the ink or paint is water-based, try it. Be sure to clean your stamp thoroughly immediately after use. Some office ink pads contain chemicals that could dry out the rubber of your stamps and should not be used.

PAPERS

A wonderful and easy way to add new dimension to your stamping projects is to use a variety of papers for layering as well as stamping. Many colors, textures, and weights are available.

*Th*e paper included in your kit is an uncoated white card stock. It is easy to use and will accept all types of ink. When purchasing paper, experiment with a few sheets before buying paper in bulk. Each paper responds to ink in its own way.

To achieve the brightest colors when using dye-based inks or pens, select a glossy or coated paper. Coated paper tends

to be slippery, so be sure to hold the paper down with one hand as you lift your stamp with the other. Pigment inks need matte paper. The absorbing qualities allow the pigment ink to dry. Some papers called "matte" are in fact "matte coated," and will not work with pigment ink unless the pigment-inked image is embossed.

*M*any different types and weights of white and colored paper are available at art stores and printers. A smooth finish is best if you wish to stamp directly on the paper. Text weight usually refers to paper suitable to layering, letter writing, or making envelopes. Cover or index stock is most often used for making cards, gift tags, boxes, etc.

*M*any specialty papers are available. Some are marbled or metallic; some are made by hand; some incorporate glitter, others have a fibrous texture. Try tearing the paper to achieve a feathered edge. With some papers, wetting the area to be torn with water using a paintbrush and a ruler will make the paper easier to tear.

Tissue paper is inexpensive and ideal for making wrapping paper. Because it is a very porous paper ink will bleed through so protect your work surface. The transparency of the paper allows the design to show on both sides. It makes a very interesting background paper when used on top of colored stock.

Sticker-backed paper, often referred to as "crack-and-peel," is available in matte or glossy finish and has the same ink requirements as regular matte or glossy paper. After stamping on sticker paper, cut out the image and affix it to your artwork for a layered look. This paper can also be used to create gifts such as bookplates, jar labels, or stickers. As your stamping experience grows, your awareness of new and interesting raw materials will develop.

Your mailbox is a great paper source. Magazines, advertisements, and junk mail often contain unusual papers. Some of these specialty papers can be printed on with ink alone, but others require embossing the image. They are also ideal to use as a decorative background to frame a stamped image or to create a col-lage. Printed cards and invitations often carry blank areas that can be used in new creations. Recycle whenever possible.

A heat gun—the most efficient tool to use for embossing.

EMBOSSING WITH INK

Embossing involves heat-treating a stamped image to create a raised, shiny, or metallic impression. It is a stunning, professional-looking technique that you will want to explore as your stamping abilities grow.

Embossing can be used to make a durable impression on all types of paper as well as on many other surfaces, such as plastic, glass, fabric, and wood. Embossed images are permanent. They do not fade with heat, light, or time.

*P*igment inks are best to use for embossing because of their slow-drying qualities. Embossing fluid, both clear and tinted, is available in a pad or dauber-topped bottle. There are embossing pens, available in many colors, with fine, calligraphic, and brush tips.

*M*any different types of embossing powders are available, and each produces a different effect. Clear embossing powder enhances the color of the ink, making it raised and shiny. Metallic and colored embossing powders will cover the ink, and tinsel powders will add sparkle. Pearl, iridescent, and psychedelic powders may modify the color of the ink used. Texture powders can give you the look and feel of cement or terra cotta. These are just a few examples of the powders currently available. New embossing powders are introduced regularly.

*Y*ou need a heat source of at least 300 degrees Fahrenheit to melt the embossing powder after you have applied it to your stamped image. The heat sources most commonly used for embossing are a heat gun, a toaster, an iron set on "cotton," an electric stove top, or an oven set at 300 degrees Fahrenheit. The commercially available "Craft Heat Gun" is the easiest and most efficient tool to use because of its steady and even heat flow. It resembles a hand-held hair dryer. Unfortunately, standard hair dryers do not get hot enough to use for embossing.

THE EMBOSSING PROCESS

*A*pply pigment ink or embossing fluid to the stamp and stamp the image on the paper. While the ink is still wet, pour embossing powder generously over the image. Make sure your hands are dry

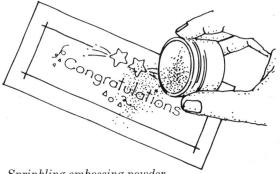

Sprinkling embossing powder on a stamped image.

and clean because the oils from your hands may transfer to the paper and catch embossing powder.

Tilt the paper and tap off excess powder to be used another time. The powder will adhere to the stamped image. Use a clean, dry, soft paintbrush to flick away any powder that sticks to areas other than the image. If you accidentally brush powder off the stamped image, reapply the powder while the ink is still wet. If you pour several jars of each of your favorite embossing powders into plastic food containers, you have the option of dipping your cards into the container for faster application. The plastic containers also work well to catch the unused powder.

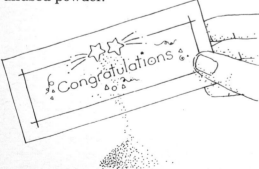

Tapping off the excess embossing powder.

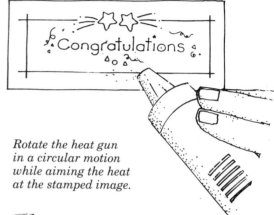

Rotate the heat gun in a circular motion while aiming the heat at the stamped image.

Hold the heat gun about 4 to 6 inches from the stamped image to melt the embossing powder. Apply the hot air in a circular motion until the entire image is embossed. You will see the powder melt and become shiny. If you are using alternate sources of heat, such as the iron, toaster, or stove top, move the paper in a slow circular motion, applying the heat to the underside. Continue heating just long enough for the powder to melt. (Of course, adult supervision is required whenever children are using any of these heat sources.)

The following tips should help you become adept at embossing.

❖ Be careful not to overheat the powder. Overheating may flatten out and dull the embossed image and/or scorch your paper.

❖ To avoid smudges, do not touch the embossed image while it is still hot. Let it cool and harden before touching it.

❖ Use a clothespin or tongs to hold small pieces of paper and to keep your fingers away from the heat source.

• An embossing pen can be used as a correction tool. Draw in areas that did not emboss, reapply powder, and heat.

❖ When you are embossing several cards at the same time, stamp and apply the powder to all of the cards before applying the heat source.

❖ If you find that the paper warps from the heat, let it cool and then flatten it by placing it under a book or heavy object and let it sit for at least an hour.

SPECIAL EMBOSSING TECHNIQUES

You can use an embossing pen or brush-tip embossing marker to highlight or fill in areas of a stamped image immediately after embossing an image. However, if your images have not been previously embossed, wait until the ink has dried completely before using the pen. Metallic or colored embossing powders will cover the color of your paper or stamped image. Try decorating an open star by filling it in with the embossing pen and then using gold powder.

You can use glue sticks to emboss stunning borders, hand-drawn designs, or written greetings. The best glue stick to use is one containing liquid glue in a pen form. These are available with various writing tips.

MULTIPLE POWDERS ON ONE IMAGE

To achieve an unusual effect, use various colors of embossing powder on the same image. Start by inking the entire stamp with one shade of pigment ink or

embossing fluid. Sprinkle the desired embossing powders, one at a time, on specific sections of the image, tapping off the excess powder before applying the next color. Heat the embossing powder only after all the colors have been applied. This technique works best with metallic powders on solid images. Try using gold, silver, and copper on a leaf or a sun for a sensational effect.

EMBOSSING A FRAME OR BORDER

For a thin, uneven border, hold the card upright and pull the edge through pigment ink or embossing fluid. Dip the card into the embossing powder and heat. For a wider border, try using a chiseled-point glue stick. Lay the card stock on your work surface. Using the edge of the card as your guide, run the glue stick along the edge to the desired thickness. In creating both types of borders, emboss only two edges at a time. This will allow you to hold the card while heating it without transferring the powders to areas you don't want to emboss. A third method to use for embossing a frame or border is to place double-sided tape on the area you want to emboss. Be sure all sections of

the tape are securely attached to your paper before applying the embossing powder. Several types of double-sided tape are available. Some produce better results than others so be sure to test your tape before applying to your card. Heat as instructed above.

To make a more whimsical frame for a stamped image, draw a line, dots, or dashes around it with a ballpoint embossing pen, using a ruler or template as a guide. If you make a mistake, remember that the black ballpoint embossing pens are erasable. Try stamping an image in each corner of your card and using the embossing pen to connect them. This technique is great for framing an address on an envelope, or names on place cards or name tags. Metallic embossing powders work best with this pen. Colored embossing pens make stunning borders when clear embossing powder is used.

DOUBLE EMBOSSING

The technique of double embossing works best for a stamped design that will be colored in. Start by embossing the

image as you would normally, using the embossing powder of your choice. Color the image using markers or colored pencils. With a clear brush-tip embossing pen or clear embossing fluid on a brush, paint a thin layer over the entire image and sprinkle with clear embossing powder. Tap off excess powder and heat for a dazzling enameled or stained-glass effect. While the image is still hot, additional powder can be applied and heated for even shinier results. You can also use the colored brush-tip embossing markers to fill in designs and then apply the clear embossing powder for the same results as above.

ADDING COLOR TO YOUR DESIGNS

WATERCOLOR PENCILS

*W*hen watercolor pencils are wet, the colors run like paint. Your artwork then looks like a watercolor painting. First, choose a stamp that has large open areas to fill in with color. Stamp the image using permanent ink, or emboss it to make it permanent.

*E*xperiment with the following methods to add interesting color to your projects:

❖ Color in the image with your watercolor pencil, just as you would with markers or regular colored pencils. Then use a clean brush or a fine-mist spray bottle to apply a small amount of water and blend the colors.

❖ To create more intense colors wet your paper and draw with dry watercolor pencils.

❖ Dip the pencil in water and draw directly on either wet or dry paper. This method produces the strongest color.

❖ You can also remove pigment from the tip of the pencil using a moistened brush and then transfer it to your stamped image, as in traditional watercolor painting. When you want to mix colors, create a palette on a separate piece of paper and blend the colors together with a wet brush. Apply the desired color with a brush to your stamped image.

*Y*ou may find that your paper curls when it is wet, but it should flatten out as it dries. If it does not dry flat, place the paper under heavy books overnight.

WATER-BASED MARKERS

*W*hen you want to achieve a lighter, more transparent look, color your markers onto a piece of aluminum foil or wax paper. Pick up the color from the foil or wax paper with a wet paintbrush. Paint in your design. You can mix the colors just as you would with any watercolor.

WATER-BASED PAINT

*W*atercolor paint can be used in the same manner as watercolor pencils. You can use pigment ink pads or pigment re-inkers as a color source. Lightly moisten your brush with a small amount of tap water. Brush the slightly moistened paintbrush over the pigment ink. Apply the color directly to your stamped design. Dip the brush into water if the ink starts to dry. Repeat the process with all the other colors until your entire design is complete.

SOFT CHALKS

*C*halks create soft, light colors. They are available pressed into squares or sticks and can be used on almost any paper stock. Apply chalk sticks as you would any crayon or

pencil. Chalk squares can be applied with your fingers, cotton swabs, sponges, etc.

BLEACH

*T*ry creating "negative" images by using bleach instead of ink. Create a pad by soaking a piece of sponge or felt in bleach. Stamp an image on dark paper and watch as the faded images appear. The shades of bleaching will vary depending upon the color and quality of paper used.

Brushing a small amount of water to blend the colors on the stamped image.

APPLYING GLITTER

An alternative to using the glitter glue you received in this kit is to use glitter and a glue stick separately. The glue stick will dry faster and is easier to control. Use glitter in many of the same ways as you would embossing powder, to create frames or borders on your cards. Glitter is available in a variety of colors and textures.

CREATING BACKGROUNDS

SPONGING

You can fashion a variety of backgrounds for stamped art, including an air-brushed effect, by using sponges. It is the texture of the sponge that gives the effect. Cosmetic, porous household and natural sponges will all work. Cosmetic sponges create a soft look, while the porous household sponge gives a mottled appearance. A background made with a natural sponge will appear lacy. There are sponges specifically designed for the purpose of creating backgrounds;

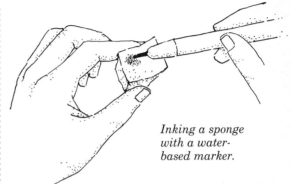

Inking a sponge with a water-based marker.

some are even on rollers. Look for these products at your local rubber stamp or craft store.

Start with a dry sponge and color it with a water-based marker. If your sponge does not have round edges, gather the whole sponge up in your fingertips to prevent edges from showing.

Blot the sponge on scrap paper to remove any excess ink and then tap it lightly all over your paper to create a soft background. For convenience, you may want to have several sponges on hand, reserving one for each color. Wash out your sponges when you are finished with a project. Experiment with mixing colors on your paper. For example, you can suggest a beautiful

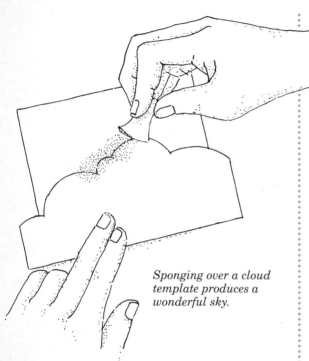

Sponging over a cloud template produces a wonderful sky.

shape found on page 61 to cut out and form a stencil. Sponge over the edge of your cloud stencil. For an overall cloudy sky, repeat the sponging, moving the stencil around on your paper. Try making patterned backgrounds by sponging over netting, a paper doily, or lace. Use sponging to fill in or to give depth to stamped grass, sand, or water. A durable stencil can be made by having the outlines we have provided on page 58-61 copied onto transparencies. These can then be wiped off as you change colors.

*T*ry this sponging technique using all types of paper, paper towels, tissue paper, or facial tissues to provide some interesting textures. Scrunch up the material in your fingers, ink it, and then tap it lightly on your paper. Each paper will produce a different effect.

sunset by lightly layering pink over a blue sky.

*Y*ou may also apply color by tapping the sponge onto an ink pad or into any other water-based ink or paint. Metallic paints give a dazzling effect to any background. Sponging over a stencil or mask of any shape is another option. Trace the cloud

SPATTERING

*S*prinkle your design with dots of color by spattering ink onto the paper with a toothbrush. Use the ink available to refill pigment ink pads, or acrylic paint. Dilute the ink with water before dipping in the

medium onto the surface. The more paint you have on your brush, the larger the dots will be. With less paint on the brush, the dots become smaller.

*S*pattering would create a wonderful background of sand for the seashells.

USING A BRAYER

A brayer is a small paint roller made out of rubber. It was originally designed for linoleum block printing, but is another great tool to use with stamping. Use it to apply ink to the surface of your stamp or directly to the paper. Brayers are available in many widths, and work well with both pigment and dye-based inks. They are the best tools available for applying a smooth background color to a paper surface. Coated paper gives the best results when using dye ink or pens.

*T*o start, cover the entire roller surface with ink, using short, sweeping strokes over the ink pad. Next, roll the brayer evenly over the paper or the card in a continuous back-and-forth motion. Repeating this process will intensify the color. Always keep scrap paper under

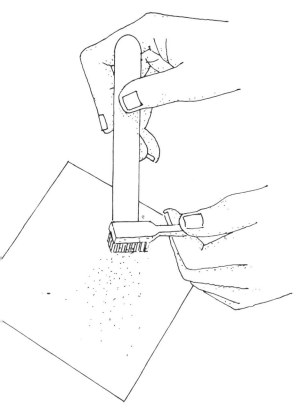

Creating a sandy background is easy using an old toothbrush to spatter the ink.

toothbrush. While holding the toothbrush over your paper, draw a knife or ice cream stick across the brush, causing the bristles to bend. As you release, the bristles spring forward and spatter the

your work so that you can roll off the edge of your artwork. Rainbow stamp pads work well for this process. With them you can create an instant sunset or beautiful background for any creation. Clean your brayer just as you would your rubber stamps.

TRY USING THE BRAYER IN THE FOLLOWING WAYS:

❖ Apply color on paper and then stamp an outlined image over the color. Cut out the image and add it to your artwork. If you have used card stock, this will give a 3-D effect. Done on sticker paper, it will offer a layered look.

❖ Obtain a "batik" effect by using wax or crayons with the brayer. First, draw a design on your paper with a waxy crayon. Then apply ink over the entire surface using the brayer. The wax from the crayon will resist ink from the brayer.

❖ Create plaids by applying different inks to your paper with small brayers, then crisscrossing horizontal and vertical stripes.

❖ Use water-based markers to draw designs directly onto the brayer. Then

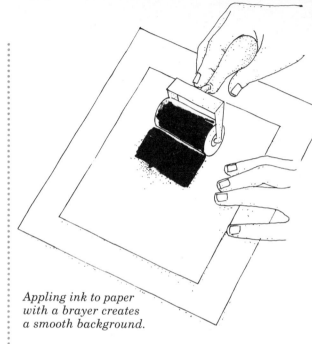

Appling ink to paper with a brayer creates a smooth background.

transfer those designs to your paper with the brayer.

❖ Ink large stamps by rolling the brayer on the ink pad and then over the stamp.

ROLLER STAMPS

Specially designed roller stamps can be used in many of the same ways as the brayer. Some are even self-inking, which is terrific when you need to cover large surfaces quickly.

REVERSING AN IMAGE

Immediately stamp the eraser or rubber surface onto paper.

𝑊hen you want an image on a stamp to face in the opposite direction, use the technique called reversing. Stamp gently onto a flat rubber surface, such as a large eraser, with pigment ink. (Pressing too hard may cause the ink to spread on the rubber.) While the ink is still wet stamp the eraser onto your artwork using extra pressure. This reverse image will be lighter in color than an initial stamping using the same ink. Therefore, if you want to print the original next to the reversed image for a mirrored effect, stamp the reversed image first and then, without re-ink-

ing the stamp, press it onto your paper. It is important to clean the eraser surface immediately after stamping. Use a damp paper towel and clean it in the same way as you clean your stamps. Flat, rubber-surfaced stamps designed specifically for reversing an image are available.

Print the original stamp on the paper last.

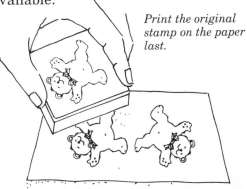

Stamp onto a flat rubber surface using pigment ink.

FABRIC STAMPING

*R*ubber stamping on fabric is a great way to personalize clothing, add dazzle to your plain napkins, and make unique gifts. You can stamp on almost any fabric, but those with smooth textures work best.

*B*efore you begin, wash the fabric to remove any sizing, but do not use fabric softeners. Iron the fabric to remove wrinkles. You may find it helpful to use an embroidery hoop to support a delicate fabric while stamping. Because the ink may bleed through the fabric, put a piece of cardboard under it before you begin. If you are working on a T-shirt, put the cardboard between the front and back of the shirt.

*I*f you are printing on a loosely knit fabric, bond freezer paper onto the wrong side of the garment to hold the fabric firm, to keep it from stretching, and also to prevent the ink from bleeding through to the back of the garment. To bond freezer paper to the fabric press the paper shiny side down with an iron set for synthetics. When your project is finished, simply pull off the paper.

*W*hen you are working on a knit garment such as leggings or tights that will be stretched when worn, you may want to stretch the fabric before stamping to avoid having a distorted image. Turn the garment inside out and stretch it to the same degree that it will be stretched when worn. To keep the fabric stretched while you work, attach self-adhesive packing tape to it where you want to stamp the designs. Turn the garment right side out. After stamping, pull the tape off and the fabric will return to its original shape.

Applying fabric paint to a rubber stamp with a small foam brush.

PERMANENT INKS

*T*here are two types of permanent ink. The first dries quickly and you must use a solvent-based cleaner to remove it from your stamps. Permanent ink is available in a dauber-topped bottle. With the dauber apply the ink directly to the stamp and then stamp onto your fabric. It is possible to apply several colors to one stamp at the same time with this product. Permanent fabric inks are also available in stamp pads which are useful for repetitive stamping of the same color. Because this ink dries quickly, the pad will require re-inking often.

*T*he second type of permanent ink is also available in stamp pads, is slow drying, and can be washed off your stamp with water. The images become permanent once they are heat-set with an iron. This ink can be used on paper when you wish to watercolor the image after stamping. Heat the image to dry the ink before applying the color.

FABRIC PAINTS

*F*abric paints come in a wide range of colors. The easiest way to apply fabric

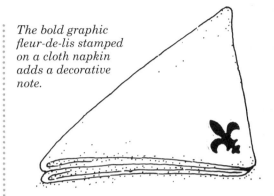

The bold graphic fleur-de-lis stamped on a cloth napkin adds a decorative note.

paint to a stamp is to use inexpensive foam brushes, sold at any paint or hobby store. Keep a supply of cotton swabs handy to clean any area of the stamp that may pick up excess paint before stamping. Because most fabric paints do not become permanent until they dry, you can clean your stamps and brushes with water while the paint is still wet. Some fabric paints require heat-setting for them to become permanent.

Stamping on transfer-inked paper.

\mathscr{F}abric paints can be used to paint or sponge directly onto the fabric prior to stamping. Use masking tape to outline areas you want to keep free of paint.

TRANSFER INK

\mathscr{T}ransfer ink allows you to stamp a design on paper and then use an iron to transfer the design to fabric. These inks are available in pads of various colors and will work on any paper. When you are happy with the images you stamped on paper, simply iron them on the fabric as directed. This ink works best on fabric that is smooth and contains some polyester.

\mathscr{D}on't forget that when you use a transfer process you will end up with a mirror image of the original design, so this technique will not work with words.

EMBOSSED PIGMENT INK

\mathscr{Y}ou can emboss any pigment ink on fabric to make it permanent. Smooth-surfaced fabrics work best because it is easier to remove any excess embossing powder from them before heating. Use

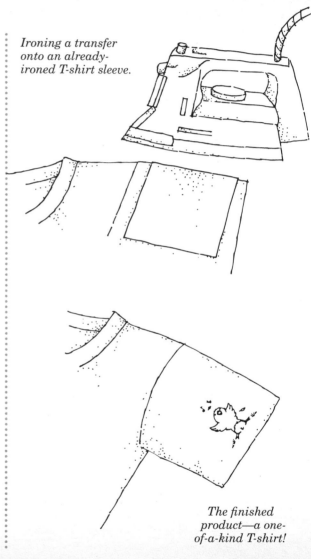

Ironing a transfer onto an already-ironed T-shirt sleeve.

The finished product—a one-of-a-kind T-shirt!

the same heat sources for fabric that you would use for paper.

The type of fabric and the method you choose will both affect the results. Therefore, always test the stamps and ink on a scrap of your fabric before beginning your project. When you want to color in an outlined image, be sure to use pens designed for fabric.

You may want to embellish your stamped designs by using fabric puff-paint and glitter pens designed to be permanent when applied to fabric. Use glue designed for fabric to affix rhinestones and trinkets.

STAMPING ON WOOD AND OTHER SURFACES

Inexpensive, unfinished wood products can be purchased at craft stores and decorated using rubber stamps. Before stamping, sand the wood to create a smooth surface. You may also decide to paint or stain the wood before starting. Plan your design keeping in mind that small images are easier to stamp on curved surfaces.

Use permanent ink or acrylic paint and test your colors on a similar type of wood, as they may produce different shades on various woods. Stamp the design and let the ink dry thoroughly before adding additional color. You can use fabric markers to color in easily or use the paint on a paintbrush. Embossing on wood will add a metallic or shiny finish to your design. Use the same techniques as for paper. (Of course the heat has to be applied from above.)

Any object that requires washing should be given a protective finish after stamping. We recommend using a spray finish because applying a fixative with a brush may cause the paint to run.

The same process that is used to stamp on wood also works well on papier-mache boxes. A stamped recipe box with matching stamped recipe cards makes a wonderful gift. You might even add some of your favorite recipes. A stamped picture frame surrounding your favorite angel makes a great gift for Grandma.

Your stamps will work on glass, metal, ceramics, or hard acrylic surfaces if you use permanent ink designed for these finishes. Pigment ink and embossing powder can be used but the image will not be as durable. Glass stains or paints are available if you wish to add color to your designs.

Clay pots can also be decorated with stamps. After wiping the pot to remove any dust, spray the outside with clear acrylic spray and let it dry. Plan your design and use fabric ink or fabric paint to stamp the pot. When the ink is dry, seal it with an acrylic spray. Insert a plastic pot into the clay pot before using it for live plants. Clay pots are also fun to use as unique gift baskets or to hold flowering bulbs like amaryllis or narcissus.

MOUNTING STAMPS

As you work with the stamps from your kit you may decide you'd like to mount them onto wood blocks. This is very easy to do. First, you need a cushion between the rubber die and the mount. There are cushions designed specifically for rubber-

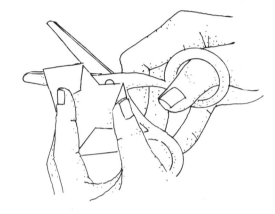

Trimming a rubber die to mount onto the wooden block.

stamp mounting, but you can also use craft foam, or even foam shoe inserts. For mounts, consider scraps of wood, wooden blocks, plastic boxes, empty thread spools, or empty jars. To begin, firmly pull the rubber die from the foam mounting and trim the die using scissors. Cut close to the design, but be careful not to undercut the image. Use rubber cement to mount the stamp to the cushion. Once the glue has set, cut the cushion to the same size or slightly larger than the die. Then, again using rubber cement, attach the cushion and stamp to your mount. Be sure that the die is parallel to the straight edge of the mount.

You can print a label, or index, on the back of a wooden block by stamping the image onto the wood prior to mounting it. You can also index the stamp by stamping on a piece of paper and attaching that to the block with heavy-duty clear tape. For accuracy in printing, it is important to place the index of your stamp in the same position on the top of your block as the die is on the bottom.

MAKING A STAMP

To create a simple design, such as a solid heart or star, cut the shape out of self-adhesive foam. It is easy to cut with scissors and will adhere to a hard surface before stamping. Compressed sponge, another material used for stamp-making, is also easy to work with. Draw your design on the sponge and cut it out. Then wet the sponge to expand its thickness. It is easier to stamp a sponge if you mount it first onto a hard surface using rubber cement. Mounting the sponge also helps keep your hands clean. Craft punches in many shapes and sizes can be used to punch fun shapes out of the sponge. Both the foam and the sponge

can be used with any ink. You can purchase foam specially designed for making stamps at most rubber stamp and craft stores.

CARVING A STAMP

To create a stamp with a lot of detail, use carving tools and large flat erasers. Draw directly onto an eraser keeping in mind that the image you stamp will be the reverse of what you carve.

Another option is to draw onto tracing paper using a soft lead pencil. Blacken the parts of the design that you want to print. Place the design face

Carving a stamp of your own design is very rewarding.

down on the eraser and firmly rub across the back of the paper with a blunt object to transfer the pencil drawing from the paper onto your eraser. This is the easiest way to carve words. Cut away the unmarked portions of the eraser. Use tools made for linoleum carving or any other small craft knives to cut the rubber. For safety, cut away from yourself. Make cuts at least 1/8 inch deep.

TEMPLATES

*Y*ou can make your own stencils by copying these templates. They are useful for creating instant interesting backgrounds for your stamping projects. You can use the templates as masks, as on page 48, or trace the outline onto your card. You can vary the size by enlarging or reducing the template on a copier.

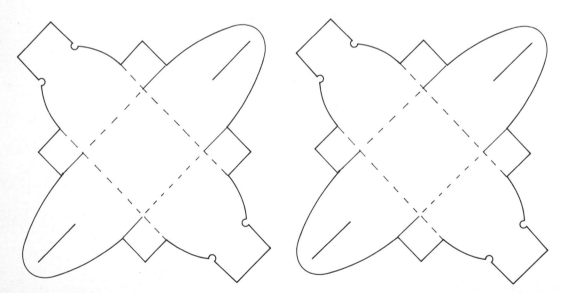

These two outlines when traced onto card stock and scored and folded as shown will create small gift boxes like the one shown in Project Number 79. Cut on the solid lines and fold on the dotted lines.

ALPHABET

Trace and use these letterforms to create additional greetings or messages to your handstamped cards or presents. This alphabet is in the same style as our "Happy," "Mother's," "Father's," "Valentines," and "Day" stamps.

A B C D E F G H I J K L

M N O P Q R S T U V W

X Y Z

Lowercase alphabet, numerals, and punctuation on following page.

a b c d e f g h i j k l
m n o p q r s t u v w
x y z

1 2 3 4 5 6 7 8 9 0
& ! ? ; . ° '

STAMP-A-GREETING™ SPECIAL PROJECTS

\mathscr{I}f you have read this far, you have all the information you need to complete the projects shown in full color on the next pages. Instructions for completing these projects follow the color pages. These projects have been planned to jump-start your creativity. You may choose to follow these instructions precisely just like a recipe and recreate these projects for yourself, or just use them as inspiration, a source book of ideas, for your own creations.

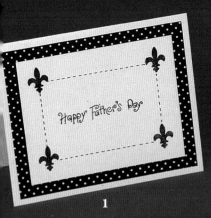

1

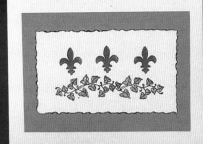

2

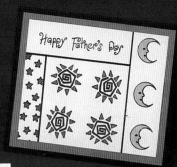

3

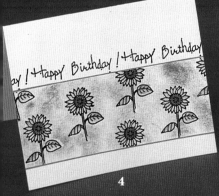

4

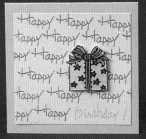

5

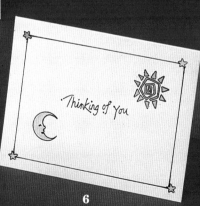

6

7

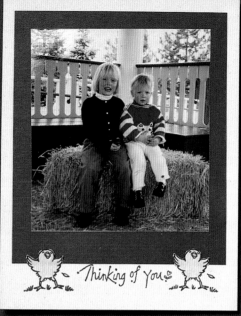

Thinking of You

8

A Star is Born!

Hannah Copple is proud
to announce the arrival
of her new baby brother!

Riley Garrison Copple
was born on April 23, 1996
at 10:00 p.m.
weighing 9 pounds 3 ounces

9

10

Thinking of You

11

12

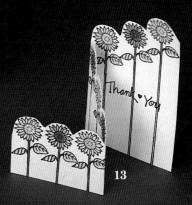

13

14

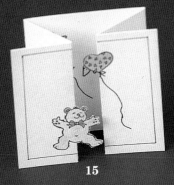

15

16

17

18

19

20

21

22

23

24

25

27

Happy Birthday !

29

30

31

32

33

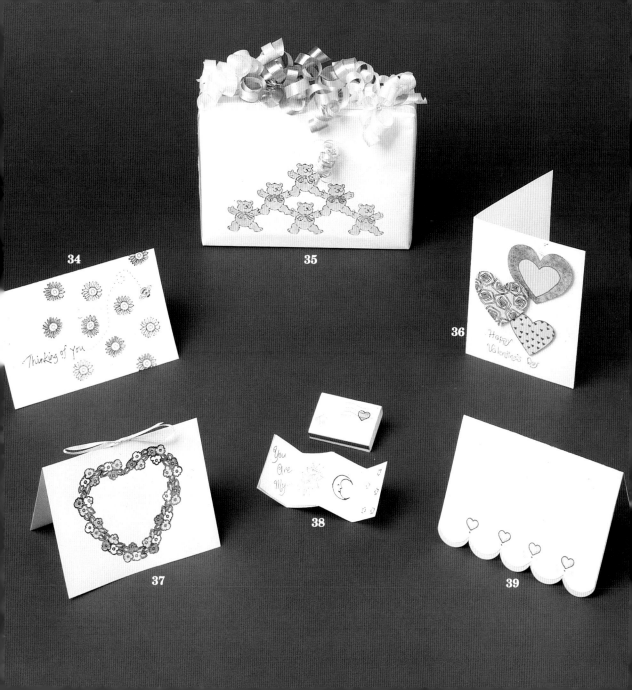

34

Thinking of You

35

36

Happy Valentine's Day

37

38

You Are My

39

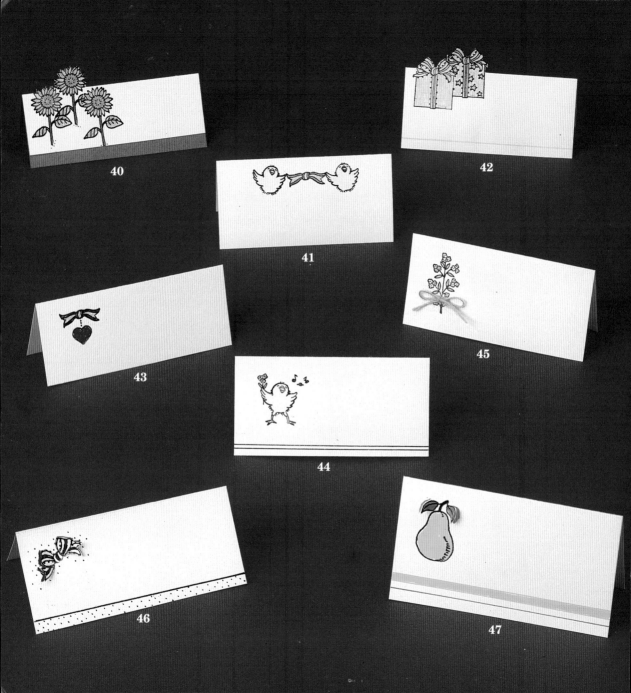

40

42

41

43

45

44

46

47

48

49

50

51

52

Thank ♥ You

53

54

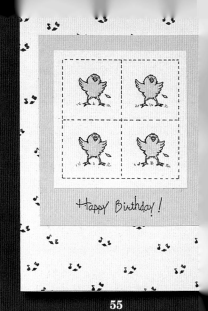

Happy Birthday !

55

56

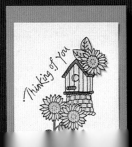

Thinking of You

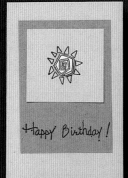

Happy Birthday !

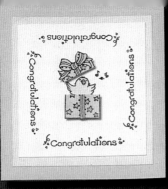

60

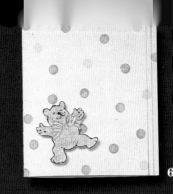

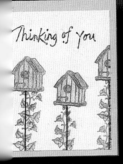

62

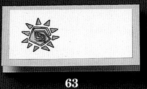

63

64

65

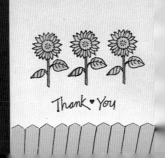

67

68

69

70

71

72

73

74

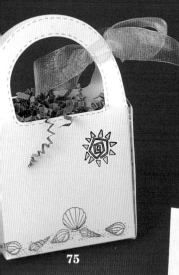

75

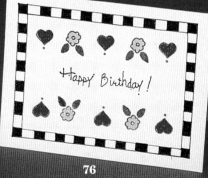

76

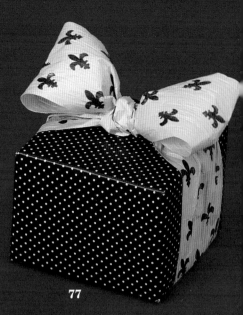

77

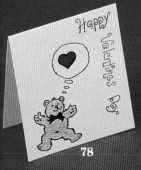

78

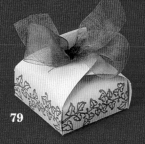

79

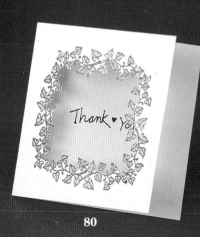

80

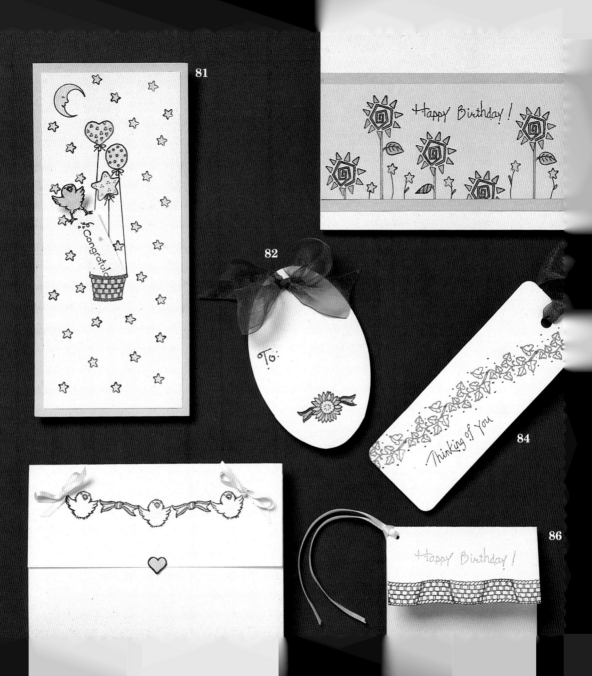

81

Happy Birthday!

82

To:

84

Thinking of You

86

Happy Birthday!

Congratul...

87

88

89

90

91

92

93

94

95

96

98

97

99

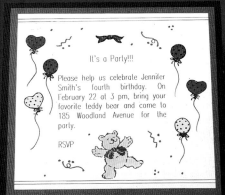

It's a Party!!!

Please help us celebrate Jennifer Smith's fourth birthday. On February 22 at 3 pm, bring your favorite teddy bear and come to 185 Woodland Avenue for the party.

RSVP

100

PROJECT NUMBER 1

STAMPS: Fleur-de-lis, "Happy," "Day," "Father's"

SUPPLIES: Card, Card Stock, Blue Brush Marker, Black Fine Tip Marker, Ruler

TIPS & TECHNIQUES: Use a marker to apply blue ink to the fleur-de-lis. Stamp it once in each corner, taking care that the images are evenly spaced. With a fine tip marker and a ruler, draw dashes connecting the fleur-de-lis. Ink the "Father's" stamp with the blue pen and place it in the center of the card. Ink "Happy" and "Day" with the blue marker and stamp them on either side of the "Father's." The background paper we used was gift wrap paper left over from the gift in Project Number 77. Use a glue stick to layer the papers.

PROJECT NUMBER 2

STAMPS: Fleur-de-lis, Ivy

SUPPLIES: Card, Card Stock, Green Brush Tip Marker, Colored Pencils, Decorative Scissors

TIPS & TECHNIQUES: Ink and stamp three fleur-de-lis, just above the center of the piece of card stock. Ink and stamp the ivy, below the center, once pointing to the left and once pointing to the right. After cleaning the ivy stamp well, ink a few leaves and stamp to fill in the middle. Color the ivy to blend with the background paper you have chosen. We have cut around the edge of the card stock with a decorative scissors. While holding the card upright in one hand, highlight the edge by gently drawing a green marker across it.

Repeat on all four sides. Use a glue stick to layer the paper.

PROJECT NUMBER 3

STAMPS: Sun, Moon & Star, "Happy," "Day," "Father's"

SUPPLIES: Card Stock, Blue Brush Marker, Fine Tip Marker, Colored Pencils, Masking Material, Glitter Glue

TIPS & TECHNIQUES: Using a fine tip marker, or dark colored pencil, divide the card into sections as you see in the sample. Mask off the area surrounding the section containing the stars. Ink the star portion of the moon & star stamp and repeatedly stamp it in the square letting some of the stars overlap the masking paper. Remember you must ink the stamp every time you use it. Remove the mask and after cleaning the stamp well, ink the moon portion and stamp three times as indicated. Stamp the sun, "Father's," "Happy," and "Day" stamps using the blue marker. Color in the sun with colored pencils to match your background paper. Once you have layered your papers, apply glitter glue to the stars, if you wish.

PROJECT NUMBER 4

STAMPS: Sunflower, "Happy Birthday"

SUPPLIES: Card, Black Ink Pad, Colored Pencils, Masking Material, Blue Brush Marker, Makeup Sponge, Fine Tip Gold Paint Pen, Ruler

TIPS & TECHNIQUES: Mask off the bottom 3/4 inch and top 2 inches of the card, taking care that the edges of the mask are parallel to the bottom of the card. Ink the sunflower in black and stamp it randomly as indicated in the sample. Make sure that some of the sunflowers are stamped partially onto the masks. Apply blue ink to the makeup sponge, remove most of the ink on scrap paper and gently tap the sponge on the paper to print a background for the sunflowers. To protect the flowers from the blue ink, make a mask of the sunflower and move it to each flower as you sponge that area. Remove all the masks and color in the sunflowers. Using a ruler and a fine tip gold paint pen, draw lines at the top and bottom of the flower section. Stamp "Happy Birthday" in black on the top portion of the card.

PROJECT NUMBER 5

STAMPS: "Happy Birthday," Gift

SUPPLIES: Card Stock, Blue & Green Brush Markers, Black Ink Pad, Colored Pencils, Foam Mounting Tape

TIPS & TECHNIQUES: With the blue marker, ink the word "Happy" on the "Happy Birthday" stamp and stamp it on the card in the upper right corner. Repeat stamping "Happy" using the sample as a guide. Clean the stamp well and color the word "Birthday" in green and stamp it as the last word. Stamp the gift on a piece of scrap card stock, color it with colored pencils, and cut it out. Cut a piece of double-stick foam tape and mount in the middle of the cut-out gift. Mount the gift on top of the card. Layer the card stock onto a card of a complementary color.

PROJECT NUMBER 6

STAMPS: Moon & Star, Sun, "Thinking of You"

SUPPLIES: Card, Black Ink Pad, Black Brush Marker, Colored Pencils, Black Fine Tip Marker

TIPS & TECHNIQUES: Stamp the "Thinking of You" stamp in the center of the card in black. Stamp the sun in black as shown in the sample. With a black marker, ink and stamp the moon. Clean the stamp well and ink only the star and place one in each corner of the card. Connect the stars with a line to form a frame. Color in the sun and stars.

PROJECT NUMBER 7

STAMPS: Bird, "Thinking of You"

SUPPLIES: Card Stock, Black & Green Brush Markers, Black Ink Pad, Colored Pencils, X-Acto Knife

TIPS & TECHNIQUES: Stamp "Thinking of You," in black, in the center, below the frame of the photograph. With markers ink the bird stamp making the grass green and the bird black. Do not ink the musical notes. Stamp once on either side of the "Thinking of You." With an X-Acto knife, cut around the wings up and over the heads and around the other wings to hold the picture. Color the bird yellow to make him a chick and layer the paper and photo.

PROJECT NUMBER 8

SUPPLIES: Star Template, Card Stock, Vellum or Tracing Paper, Black Brush Marker, X-Acto Knife, Ribbon, 1/8-inch Hole Punch

TIPS & TECHNIQUES: Use your printer to type the words on the yellow card stock. Fold over 1 1/4 inches of the yellow paper. Cut the tracing or vellum paper to fit under the folded-over section. Copy and trace the star template to create the stars. Place the drawn stars in several places on the tracing or vellum paper making sure they are not covering the words. Use your X-Acto knife to cut out the stars. Punch two holes through all three layers of paper and tie with a bow. We started the ribbon from the top, went down both holes, then across and up through the opposite hole.

PROJECT NUMBER 9

STAMPS: Bear, Bow

SUPPLIES: Card Stock, Black Ink Pad, Black & Red Brush Markers, X-Acto Knife, Black Fine Tip Marker

TIPS & TECHNIQUES: Ink the bear stamp in black and stamp it in the lower left corner of the card. With an X-Acto knife, cut from the middle of his head to under his arm to hold the picture. Because our baby came from China, we made the bear a panda by coloring his arms, legs, ears, and eyes with a black pen. Ink the bow in the black pad, stamp it, and cut out the bottom edge to hold the upper right corner of the picture. Color the bow to match your picture.

PROJECT NUMBER 10

STAMPS: Seashells, "Thinking of You"

SUPPLIES: Card Stock, Black Brush Marker

TIPS & TECHNIQUES: Mark the size of your picture with a pencil. Ink only the largest shell on the seashell stamp and stamp it in all four corners. With an X-Acto knife cut around the shells to hold the picture. Stamp "Thinking of You" in the center at the bottom and add smaller shell stamps, inked with a marker, on either side.

PROJECT NUMBER 11

STAMPS: Gift, "Happy Birthday"

SUPPLIES: Card, Black Ink Pad, Black Brush Marker, Colored Pencils, X-Acto Knife, Pencil, Paper Clip

TIPS & TECHNIQUES: Ink the gift stamp with the black pad and stamp it six times as indicated in the sample. Color the ribbons. With an X-Acto knife cut around the top, bottom, and right sides of the two end gifts on the top row and the middle gift on the bottom row. Place a ruler along the uncut side and with a paper clip score along the edge of the gift. Scoring the paper will make it easier to open the three gifts like little doors. With a pencil, lightly mark through the open gifts to the inside of the card. With a marker, ink the "Happy" of the "Happy Birthday" stamp and

stamp it three times so it will show through each opened gift. Ink and stamp "Birthday" on the inside after the last "Happy."

PROJECT NUMBER 12

STAMPS: Heart & Dot

SUPPLIES: Card Stock, Black Brush Marker, White Pencil

TIPS & TECHNIQUES: Ink the heart of the heart & dot stamp with the black marker and stamp it randomly across the bottom, below the picture. Color in the hearts with a white pencil and frame the picture with dashes drawn with a white pencil.

PROJECT NUMBER 13

STAMPS: Sunflower, "Thank You"

SUPPLIES: Card Stock, Black Ink Pad, Colored Pencils, Black Fine Tip Marker, Ruler, Paper Clip or Bone Folder

TIPS & TECHNIQUES: Start with a piece of card stock 11 inches long and at least 6 inches high. Starting on the left side, ink and stamp three sunflowers in a row, all at the same height. With a ruler and a paper clip, score the paper vertically just after the last flower stamp. Cut out around the top of the flowers and fold on the scored line. At this point I like to cut flowers out of scrap paper and move them around to determine where they should be stamped. Ink and stamp the next three flowers, cut around them and score so the second fold is the same size as the first fold. Now turn the card over and stamp flowers on the back of the last three you stamped. You should be able to see these above the first three when you close the card. Open the card again and stamp the last three flowers. Cut around the last three flowers and trim the card if the back section extends beyond the first two. With a black fine tip marker, extend the stems and color the flowers. Stamp "Thank You" on the inside.

PROJECT NUMBER 14

STAMPS: Floral Filler, Basket, Flower Cluster

SUPPLIES: Card, Card Stock, Black Brush Marker, Colored Pencils, Double-Stick Mounting Tape

TIPS & TECHNIQUES: Stamp one basket and the floral clusters several times on scrap card stock. Color and cut them out. Cut a piece of mounting tape and use it to mount the basket on the card. Stamp the floral filler three times above the flower basket. Arrange the bouquet and use mounting tape to fasten the flowers to the card. Put two pieces of mounting tape on some of the flowers to make them appear three-dimensional.

PROJECT NUMBER 15

STAMPS: Bear, Balloons

SUPPLIES: Card Stock, Black Ink Pad, Black Brush Marker, Black Fine Tip Marker, Colored Pencils, Ruler, Pencil, X-Acto Knife, Scoring Tool

TIPS & TECHNIQUES: Take a piece of card stock 11 by 4 1/4 inches. Using a ruler and a bone folder or scoring tool, score a vertical line 3 3/4 inches in from both narrow ends of the card stock and fold toward the center. The center space will be 3 1/2 inches wide. Opening the card, measure from the fold 1 3/4 inches out toward each end and mark lightly with a pencil. This will be where the outside of the card will fold back. Do not fold yet! Stamp the bear at the mark so that one half will be on each side when you fold it. Stamp the balloon, inked with a pen on the opposite side just as you did the bear. Color everything in. With a ruler score the card at the mark, but do not score through the bear or balloon. Do not fold it yet! With an X-Acto knife cut the right side of the bear and the left side of the balloon out up to the score line. Now you can fold on the score line and the bear and the balloon will stand out. Trim the outside edge if you wish. With a fine tip marker, and the card closed, draw a frame around the front of the card. Draw a tail for the balloon. Stamp the inside of the card with balloons and "Happy Birthday."

PROJECT NUMBER 16

STAMPS: Sun, "Happy Birthday"

SUPPLIES: Card Stock, Black Marker, Colored Pencils

TIPS & TECHNIQUES: Ink the swirl center of the sun and stamp as shown. Carefully clean the stamp and then ink one triangle and stamp it several times to fill in. Stamp the "Happy Birthday" and color the swirls and triangles to coordinate with the colored card stock you are using.

PROJECT NUMBER 17

STAMPS: Bee, "Happy Birthday," Sunflower

SUPPLIES: Card Stock, Red Fine Tip Marker, Black Ink Pad, Colored Pencils

TIPS & TECHNIQUES: Using the red marker and a ruler or a positioner as a guide, stamp the "Happy Birthday" repeating it evenly in four rows diagonally across the card. Start the fifth row above the rest and stamp just the end of the "Happy Birthday." Stamp the bee above and the sunflower below the rows of "Happy Birthday" using the black ink pad. Use the red marker to draw dashes from the end of the "Happy Birthday" to the bee so that he looks as though he wrote the greeting. Color in the bee and the sunflower using the colored pencils.

PROJECT NUMBER 18

STAMPS: Floral Sprig, Birdhouse, Bird, "Thank You"

SUPPLIES: Card Stock, Black & Red Brush Markers, Fine Tip Gold Paint Pen, Colored Pencils, Black Fine Tip Marker

TIPS & TECHNIQUES: Build the tree using the floral filler inked with the black marker. Color or sponge the tree using green pencils or markers. Stamp the birdhouse as shown and draw a line with the fine tip black marker to hang it from the tree. Ink the bird with the black marker, but do not ink the notes, and stamp it below the birdhouse. Ink the heart in the "Thank You" stamp and stamp it twice above the bird. Draw a line with the gold paint pen along the opening edge of the card. Color with colored pencils.

PROJECT NUMBER 19

STAMPS: Heart Design, "Happy Birthday"

SUPPLIES: Card, Card Stock, Black Ink Pad, Colored Pencils, Blue Brush Marker, Ruler, Foam Mounting Tape

TIPS & TECHNIQUES: Create a background with a blue pencil by drawing lines vertically on the front of the card every 3/4 inch. Ink the heart design in black and stamp between the lines as indicated in the sample. Color the heart and leaves to coordinate with the card stock you have selected for the "Happy Birthday" stamp. Stamp "Happy Birthday" on card stock and mount it to the card with foam mounting tape.

PROJECT NUMBER 20

STAMPS: Single Flower, "Thinking of You"

SUPPLIES: Card, Black & Green Brush Markers, Black Ink Pad, Colored Pencils

TIPS & TECHNIQUES: Ink the leaves of the flower stamp in green and the flower in black and stamp as shown in the sample. Stamp the "Thinking of You" in black in the center of the card. Color in the flowers.

PROJECT NUMBER 21

STAMPS: Bear, Floral Filler, "Congratulations"

SUPPLIES: Card Stock, Black Brush Marker, Colored Pencils

TIPS & TECHNIQUES: Stamp the bear stamp twice, rotating the stamp for the second impression to make the bear look like he is tumbling. Using the black marker ink the "Congratulations" stamp (do not ink the confetti) and stamp it above the bear. Ink just one flower of the floral filler and stamp to create a background. Color in with colored pencils.

PROJECT NUMBER 22

STAMPS: Flower Cluster

SUPPLIES: Place Card, Card Stock, Black & Green Brush Markers, Colored Pencils

TIPS & TECHNIQUES: Stamp as per Project Number 20. Layer place card onto colored card stock and color in flowers to coordinate.

PROJECT NUMBER 23

STAMPS: "Thinking of You," Sunflower

SUPPLIES: Card Stock, Black Brush Marker, Black Ink Pad, Scissors or X-Acto Knife, Colored Pencils

TIPS & TECHNIQUES: Ink only the flower of the sunflower stamp and stamp five times to form a free-flowing border along the bottom of the card. Clean the stamp and ink only the leaf of the sunflower. Stamp to fill in. Cut along the bottom edge of border. Stamp the "Thinking of You" stamp above the flowers.

PROJECT NUMBER 24

STAMPS: Floral Cluster, Floral Filler, Bow

SUPPLIES: Card, Card Stock, Black Brush Marker, Black Fine Tip Marker, Colored Pencils, Decorative Scissors

TIPS & TECHNIQUES: Stamp flowers on a piece of light-colored card stock, using the black brush marker. Stamp the floral cluster in the shape of a triangle as indicated in the sample. With a marker, ink one of the flowers and stamp to round out the bouquet. Next, ink part of the floral filler and fill in as appropriate on the top of the flowers. Ink the bow and stamp below the bouquet. Draw stems using a fine tip marker. Color in the flowers with colored pencils. Trim the card stock with decorative scissors and draw dots to highlight the edge. Add a few dots to the bouquet to make it more appealing. Mount on colored paper.

PROJECT NUMBER 25

STAMPS: Sunflower

SUPPLIES: Card Stock, Black Ink Pad, Black Fine Tip Marker, Ribbon, Colored Pencils, Masking Supplies

TIPS & TECHNIQUES: Stamp the sunflower in the center of the card. Prepare a mask of the sunflower blossom. Using masking techniques, stamp the sunflower two more times on the card. Using a fine tip marker lengthen the stems. With an X-Acto knife, make a small slit on each side of the stems for the ribbon. Thread the ribbon, and tie the bow before layering paper. Color in the sunflowers with colored pencils.

PROJECT NUMBER 26

STAMPS: Floral Cluster, "Happy Birthday"

SUPPLIES: Card, Pencil, Black Ink Pad, Colored Pencils

TIPS & TECHNIQUES: With your pencil, lightly draw an oval shape on the card. Stamp the flowers repeatedly along the oval pencil line. Stamp "Happy Birthday" inside the frame and color in the flowers.

PROJECT NUMBER 27

STAMPS: Floral Cluster

SUPPLIES: Envelope, Black Ink Pad, Colored Pencils

TIPS & TECHNIQUES: Open the envelope and

lay it flat on your work surface. Stamp the flowers along the edge of the envelope flap. Cut along the outside edge of the flowers and color to coordinate with your card.

PROJECT NUMBER 28

STAMPS: Floral Filler, Basket

SUPPLIES: Card Stock, Black Ink Pad, Colored Pencils, Masking Supplies, Decorative Scissors

TIPS & TECHNIQUES: Stamp the basket near the bottom of the card. Prepare a mask of the basket. Ink and stamp the floral filler partially over the masked basket. Stamp again above the first forming a vertical line. Stamp again twice to form a horizontal line at the point where your first stamps meet. Fill in with two diagonal stamps of the floral filler as shown. Color in with colored pencils. Trim with decorative scissors when layering paper.

PROJECT NUMBER 29

STAMPS: Ivy, "Thinking of You"

SUPPLIES: Card, Embossing Powder, Embossing Pen, Pigment Ink, Black Ink Pad, Embossing Supplies, Colored Pencils, Ruler

TIPS & TECHNIQUES: Stamp ivy at right angles to form a corner. Emboss using gold embossing powder. Heat and repeat at the opposite corner. Draw lines to form a frame with the embossing pen and a ruler. Emboss with gold powder. Stamp "Thinking of You" using black ink. Color in the ivy.

PROJECT NUMBER 30

STAMPS: Balloon, Bow, "Congratulations"

SUPPLIES: Card, Card Stock, Black Ink Pad, Black Fine Tip Marker, Colored Markers, Glitter Glue

TIPS & TECHNIQUES: Stamp the balloon using the black brush marker. Only ink the outline of the balloon. Prepare a mask and stamp the balloon repeatedly to form a bouquet. Stamp bow and draw the strings with a fine tip marker. Color in the balloons. Layer papers and lastly, apply glitter glue to highlight the balloons.

PROJECT NUMBER 31

STAMPS: Seashells

SUPPLIES: Card Stock, Card, Gold Embossing Powder, Pigment Ink, Embossing Supplies, Decorative Scissors

TIPS & TECHNIQUES: Stamp shells in the center of the card and emboss. Repeat on either side. For best results emboss each stamped image separately. Trim stamped card stock with decorative scissors and layer paper.

PROJECT NUMBER 32

STAMPS: Pear, "Happy Birthday," Small Heart Design

SUPPLIES: Card, Black Ink Pad, Colored Pencil

TIPS & TECHNIQUES: Stamp the pear in the center along the bottom of the card. Stamp again on either side. Fill in with the small heart design. Stamp "Happy Birthday" and color in with markers.

PROJECT NUMBER 33

STAMPS: Gift, "Happy Birthday"

SUPPLIES: Card, Colored Paper, Black Ink Pad, Double-Stick Foam Mounting Tape, Ruler

TIPS & TECHNIQUES: Using your ruler as a guide, stamp "Happy Birthday" diagonally across the card. Repeat in rows to complete background. Stamp the gift on card stock, color in, and cut it out. Layer papers and mount gift with mounting tape.

PROJECT NUMBER 34

STAMPS: Bee, "Thinking of You," Sunflower

SUPPLIES: Card, Black Brush Marker, Black Fine Tip Marker, Black Ink Pad, Colored Pencils

TIPS & TECHNIQUES: Stamp "Thinking of You" on the left side of the card. Inking only the blossom portion of the sunflower stamp, stamp randomly on the card as in the example. Stamp the bee toward the right side of the card. Using the fine tip marker draw dashes to indicate the bee's flight pattern through the flowers. Add color with pencils.

PROJECT NUMBER 35

STAMPS: Bear

SUPPLIES: Wrapping Paper, Black Ink Pad, Colored Pencils, Curling Ribbon, Toothpick, Glue

TIPS & TECHNIQUES: Stamp three bears on scrap paper and cut out each to use as a guide for positioning the bear pyramid. Position the guide bears so that the upper bear's feet meet the bottom bear's hands. Remove the guides and stamp. Repeat to form a large pyramid as shown. Color in the bears. Make a pom-pom using shredded curling ribbon glued onto a round toothpick. Glue the toothpick to the top bear's hand. Wrap the gift.

PROJECT NUMBER 36

STAMPS: Sun, "Valentines," "Happy," "Day," "Thank You"

SUPPLIES: Pink Card Stock, Black Ink Pad, Paper Towels for Sponging, Double-Stick Foam Mounting Tape, Gold Paint Pen, Red Brush Marker

TIPS & TECHNIQUES: Using the heart template as a guide, draw three hearts on pink card stock. You'll want different sizes so copy the heart shape on a copier, reducing and/or enlarging to vary the sizes. For the heart in the upper corner, prepare a heart-shaped mask for the center. Sponge the heart using a scrunched-up paper towel and red ink from the brush marker. Outline the masked heart with a gold paint pen. The center heart is dec-

orated using the center of the sun inked with the red brush marker and stamped repeatedly for an overall design. Highlight with the gold paint pen. The last heart is stamped by inking only the heart of the "Thank You" stamp with the red marker. Outline the heart with the gold paint pen. Cut out the three hearts and mount with mounting tape. Stamp "Happy" "Valentines" "Day" using the black ink pad. Add an apostrophe to "Valentines."

PROJECT NUMBER 37

STAMPS: Floral Cluster

SUPPLIES: Card, Ribbon, Black Brush Marker, Black Ink Pad, Colored Pencil, Pencil, Heart Template, 1/8-inch Hole Punch

TIPS & TECHNIQUES: Lightly trace a heart shape in the center of the card using the template. Using the outline as your guide, stamp the floral cluster along the line to form a wreath. Color in flowers and leaves with colored pencils. Punch two holes fairly close together on the fold line. Thread narrow ribbon through holes and tie a bow.

PROJECT NUMBER 38

STAMPS: Heart & Dot, Sun, Moon & Star

SUPPLIES: Small Matchbox (white if possible), Card Stock, Black Fine Tip Marker, Black Brush Marker, Colored Pencils, Wave Template, Glitter Glue

TIPS & TECHNIQUES: If you cannot find a white matchbox, cover one with white paper. Stuff something hard into the matchbox to create a firm stamping surface. Ink the heart with the black brush marker and stamp in the upper right-hand corner (where you would place a postage stamp). Draw four wavy lines across the heart to simulate a postage cancellation using the template of a wavy line. For the card, measure the dimensions of the interior of the matchbox and cut a length of card stock four times the matchbox width. Fold in half and in half again to form an accordion fold. Page 1: Following the alphabet guide in this book, letter "You are my." Page 2: Stamp the sun using the black ink pad. Page 3: Stamp the moon with the black brush marker. Page 4: Stamp the stars using the black brush marker. Color in with pencils, apply glitter glue to the stars, and give to your sweetheart.

PROJECT NUMBER 39

STAMPS: Heart & Dot, Single Flower

SUPPLIES: Colored Card Stock, Card, Black Ink Pad, Green Brush Marker, Glue or Double-Stick Tape

TIPS & TECHNIQUES: Trace the scallop pattern from the template approximately 1/4 inch above the bottom edge of the card and cut out. Cut a piece of colored card stock the same size as the card and cut scallops at the bottom edge. Attach the colored card stock under the front of your card using glue or double-stick tape. Ink only the leaves of the flower stamp with your green brush marker and stamp at the point of each scallop. Ink the heart with

the black brush marker and stamp above each pair of leaves to form a flower. Color in with colored pencils.

PROJECT NUMBERS 40–47

SUPPLIES: Card Stock, X-Acto Knife, Various Colored Pencils and Markers, Black Ink Pad, Ruler

TIPS & TECHNIQUES: These samples show just a few of the place cards that can be made. Some of these use a cutting technique where you measure the center line of the paper and lightly mark it. Stamp your images over the center line of the card. Score the card on the center line but do not score over the stamped images. Read about scoring in the pop-out section. Cut with your X-Acto knife from the score line up and over the design and back to the score line. When you fold the card, your stamped image will appear to pop up.

PROJECT NUMBER 48

STAMPS: Floral Cluster, Floral Filler

SUPPLIES: Card, Card Stock, Black Ink Pad, Colored Pencils or Markers, Piece of Newspaper, Decorative Scissors, Foam Mounting Tape

TIPS & TECHNIQUES: Stamp the floral cluster three times on card stock, color them in and cut them out. Cut a piece of newspaper in a fan shape about 2 inches at the bottom and 4 inches at the top. Fold it as a wrap for the flower bouquet. Stamp the floral filler on the card stock as a background for the bouquet, using the newspaper wrap as your guide. Glue the newspaper in the center of the card stock, and using the mounting tape, arrange the cut-out flowers to form the bouquet. Cut along the edge of the card with decorative scissors and layer papers to form the card.

PROJECT NUMBER 49

STAMPS: Bear, Balloons

SUPPLIES: Card Stock, Black Ink Pad, Black Brush Marker, Black Fine Tip Marker, Colored Pencils

TIPS & TECHNIQUES: Stamp the bear and ink one balloon at a time and position them above the bear as indicated in the sample. With a black marker, color in the bear to make him a panda. Color the balloons and the bear's bow with colored pencils and draw the strings with the fine tip marker. Mount on colored card stock.

PROJECT NUMBER 50

STAMPS: Sunflower, Bee

SUPPLIES: Card Stock, Black Ink Pad, Black Fine Tip Marker, Fine Cord or String, Darning Needle, Three Buttons, Colored Pencils or Markers

TIPS & TECHNIQUES: With an ink pad, stamp three sunflowers in a row, just slightly off center allowing enough room for the bee to be stamped on the left side. With the fine tip marker, draw dashes to indicate the flight

pattern of the bee. Color everything in and sew buttons in the center of each flower. Layer the card.

PROJECT NUMBER 51

STAMPS: Floral Filler, "Happy," "Day," "Mother's"

SUPPLIES: Card Stock, Green Brush Marker, Black Ink Pad, Black Fine Tip Marker, Colored Pencils

TIPS & TECHNIQUES: Stamp "Happy" "Mother's" "Day" in the center of the card. With the black fine tip marker draw dashes to frame the words. Around the dashes repeatedly stamp the floral filler in green to frame the card. Color in the flowers and layer the paper to form the card.

PROJECT NUMBER 52

STAMPS: Pear, "Thinking of You"

SUPPLIES: Card Stock, Black Ink Pad, Colored Pencils, Scissors or X-Acto Knife

TIPS & TECHNIQUES: Stamp, in black, the pear five times along the bottom edge of the card. Stamp "Thinking of You" in the center above the pears. Color in the pears and cut around the bottom edge to form a scallop.

Thinking of you

PROJECT NUMBER 53

STAMPS: Pear, "Thank You"

SUPPLIES: Card, Card Stock, Black Ink Pad, Colored Pencils or Markers, Decorative Scissors

TIPS & TECHNIQUES: Randomly stamp, in black, the pear on the card to form a background. On the card stock, stamp a single pear with "Thank You" above it. Color in the single pear to match the background color. Cut the edge of the card stock with the decorative scissors, and run a green pen along the edge to form a frame. Glue the card stock onto the card.

PROJECT NUMBER 54

STAMPS: Bird, Birdhouse, Sun

SUPPLIES: Card, Black Brush Marker, Black Fine Tip Marker, Colored Pencils

TIPS & TECHNIQUES: Stamp the sun in the upper right corner, and the birdhouse in the lower right. Both should be slightly off the card. With the black brush marker, ink the bird so he appears to be flying by not inking his feet or the grass. Stamp him three times. Draw a straight black line down from the birdhouse to make a pole. Color everything with colored pencils.

PROJECT NUMBER 55

STAMPS: Bird, "Happy Birthday"

SUPPLIES: Card, Card Stock, Black Fine Tip Marker, Black Brush Marker

TIPS & TECHNIQUES: With the black brush marker, ink only the notes on the bird stamp and randomly stamp notes all over the card for the background. On a square piece of card stock, use a black fine tip marker to draw dashes 1/4 inch inside all four sides. Divide the card stock in four sections by drawing a line of dashes vertically and horizontally. With a black brush marker, ink the bird (not the notes) and with a green marker ink the grass and then stamp the bird once in each section. Mount the square near the top of a piece of oblong colored card stock and stamp "Happy Birthday" below the square. Color the bird yellow to make him a chick. Layer the colored card stock onto the card.

PROJECT NUMBER 56

STAMPS: Bear, Basket

SUPPLIES: Card, Black Ink Pad, Colored Brush Marker, Colored Pencils, New Pencil Eraser, Fine Tip Colored Markers

TIPS & TECHNIQUES: Stamp the basket upside down on the card. Stamp the bear with one foot on the basket. Apply ink to the top of a new pencil eraser with colored brush markers and stamp to form balls above the bear's head. Draw oblong boxes around the bear with colored pencils to form a frame. Color in the bear and basket.

PROJECT NUMBER 57

STAMPS: Ivy, Basket

SUPPLIES: Card, Card Stock, Green & Brown Brush Tip Markers, Colored Pencils, Piece of Ribbon, Pencil, Masking Supplies

TIPS & TECHNIQUES: With a brown brush tip marker, ink the basket and stamp it near the bottom of the piece of card stock. Prepare a mask of the basket. Ink the ivy stamp with a green brush tip marker and stamp it above the basket with part of the ivy being stamped over the mask. With a pencil draw a light line in the shape of a heart above the stamped ivy. Continue inking and stamping portions of the ivy to fill the pencil shape. Color everything in and layer the card as indicated in the sample. Note: If you do not have brown and green brush markers, black can be used.

PROJECT NUMBER 58

STAMPS: Birdhouse, Basket, Sunflower, "Thinking of You"

SUPPLIES: Card Stock, Black Brush Marker, Foam Mounting Tape, Masking Supplies

TIPS & TECHNIQUES: Using the sample as a guide, stamp a black sunflower just off center, near the bottom of the card stock. Prepare a mask of the sunflower and stamp the second sunflower to the left and just behind the first one. Mask the second sunflower and with both flowers masked, stamp the basket, upside down, slightly above and to the right of the flowers. When you remove the masks, it will

appear to be behind the flowers. Stamp the birdhouse on top of the basket. Color everything. Stamp another sunflower on a separate piece of card stock, color, and cut it out. Attach it to the card with mounting tape. Stamp "Thinking of You" diagonally across the card. Mount the card stock on a colored card.

PROJECT NUMBER 59

STAMPS: Sun, "Happy Birthday"

SUPPLIES: Card Stock, Black Ink Pad, Foam Mounting Tape

TIPS & TECHNIQUES: On a square piece of card stock stamp the sun in black. On light card stock, stamp the sun and cut out only the center. Color in center design and mount it over the first sun using foam mounting tape. Layer the card stock and stamp "Happy Birthday" on the second layer.

PROJECT NUMBER 60

STAMPS: Bird, Gift, "Congratulations"

SUPPLIES: Card Stock, Black Ink Pad, Black Brush Marker, Colored Pencils, Foam Mounting Tape

TIPS & TECHNIQUES: Ink only the bird and stamp it in the center of the light card stock. Color him yellow to make him a chick. Stamp the gift on colored card stock, color, cut it out, and cut in two so it appears to be a box and lid. Mount it on the card with mounting tape. Ink only the notes on the bird stamp and stamp them as shown on the sample. Stamp the "Congratulations" on all four sides as shown in the sample. Layer the card stocks to form a card.

PROJECT NUMBER 61

STAMPS: Bear

SUPPLIES: Card, Card Stock, New Pencil Eraser, Colored Brush Markers, Black Ink Pad, Colored Pencils, Foam Mounting Tape, Ruler

TIPS & TECHNIQUES: Ink the top of a new pencil eraser with brush markers and randomly stamp in pastel colors all over the card. Using a ruler and colored pencil draw two lines along the right opening edge of the card. Stamp the bear on a separate piece of card stock, color, cut out, and mount it to the card using mounting tape.

PROJECT NUMBER 62

STAMPS: Birdhouse, Ivy, "Thinking of You," Sun

SUPPLIES: Card Stock, Black Ink Pad, Green Brush Marker, Colored Pencils, Black Fine Tip Marker

TIPS & TECHNIQUES: Stamp four birdhouses across the card at various heights and color them in. With the black fine tip marker, draw poles for the birdhouses. Ink the ivy stamp in green and stamp it along each pole. If you do not have a green brush marker, you can use a black one. Stamp the sun in the upper left corner, partially off of the paper. Color in the sun

and ivy. Stamp "Thinking of You" above the birdhouses.

PROJECT NUMBER 63

STAMPS: Sun

SUPPLIES: Place Card, Card Stock, Black Ink Pad, X-Acto Knife, Colored Pencils, Double-Stick Tape

TIPS & TECHNIQUES: Stamp the sun on the left side of white card stock. Using your X-Acto knife, cut following the lines of the center design of the sun to create a coil-like piece of paper. Mount the white card onto a contrasting piece of card stock, which you have cut to the size of your place cards and folded, using double-stick tape. Add color to your sun, if desired, with colored pencils.

PROJECT NUMBER 64

STAMPS: Single Flower, Bee

SUPPLIES: Card, Card Stock, Black Brush Marker, Green Brush Marker, Scissors, Colored Pencils

TIPS & TECHNIQUES: Cut three pieces of white card stock 1 inch wide by 4 inches long. Cut four pieces of colored card stock 1 inch wide by 3 inches long. Weave them together as shown in the sample. With brush markers stamp the single flower black and the leaves green and stamp on five of the white squares. On the sixth square, stamp the bee in black. Color in the flowers and bee and mount on white card stock layered onto a colored card.

PROJECT NUMBER 65

STAMPS: Sun, Flower Filler

SUPPLIES: Card, Card Stock, Black & Green Brush Markers, Button, Thread, Colored Pencils, Decorative Scissors

TIPS & TECHNIQUES: With a green marker on white card stock, color the top of the floral filler and stamp it along the bottom of the paper. Stamp the sun in black. Color the flowers and sun and sew a button as the center of the sun. Trim the paper with decorative scissors and mount onto a colored card.

PROJECT NUMBER 66

STAMPS: Sunflower, "Thank You"

SUPPLIES: Card Stock, Black Brush Marker, Colored Pencils, Pencil, Ruler, Black Fine Tip Marker

TIPS & TECHNIQUES: Score and fold the card stock so that two-thirds of the card is the part with the flowers and one-third of the card is folded up as the fence. When closed the flowers will appear to be behind the fence and when open you see the "Thank You." Using the fence template, cut the top of the fence. With a ruler and black fine tip marker, draw lines to complete the fence. Stamp three sunflowers across the middle of the card and color them in. Stamp "Thank You" near the bottom of the card.

Thank ♥ You

PROJECT NUMBER 67

STAMPS: Pear

SUPPLIES: Small Kraft Candy Bag, Black Ink Pad, Colored Markers, Ribbon, 1/8-inch Hole Punch

TIPS & TECHNIQUES: Before you begin to stamp, place a piece of cardboard inside the bag. Using the black ink pad, stamp three pears across the bottom of the bag and color them in with markers. Fill the bag, fold the top over, and punch two holes in the center near the top. Thread the ribbon through from the back and tie a bow.

PROJECT NUMBERS 68 & 69

STAMPS: Seashells, Sun

SUPPLIES: Ribbon, Pigment Ink, Gold Embossing Powder, Embossing Supplies

TIPS & TECHNIQUES: Ink the stamp with pigment ink and randomly stamp along the ribbon. Following the embossing instructions, emboss the images. It works best to emboss two or three images at a time, being careful to brush off all excess powder before heating.

PROJECT NUMBER 70

STAMPS: Ivy

SUPPLIES: Wrapping Paper, Green Brush Marker, Organdy Ribbon, Ruler

TIPS & TECHNIQUES: Cut the wrapping paper to the size needed to wrap the package and crease the paper on the edges. Take the paper off the box and use the creases as a guide to place the images. Ink the ivy stamp with a green brush marker and using the ruler, stamp diagonally until the paper is covered. Wrap the present and tie with a green ribbon.

PROJECT NUMBER 71

STAMPS: Sun

SUPPLIES: Key Tag, Blue Brush Marker, Pigment Ink, Silver Embossing Powder, Embossing Supplies

TIPS & TECHNIQUES: Ink the sun stamp with pigment ink and emboss with silver embossing powder. Color the background with a blue brush marker.

PROJECT NUMBER 72

STAMPS: Pear

SUPPLIES: Small Kraft Box, Black Ink Pad, Organdy Ribbon

TIPS & TECHNIQUES: Fold the box flat or place a firm object inside to insure the best image when you stamp. Ink the pear stamp in black ink and stamp one pear on each side of the box. Randomly stamp the pear along the ribbon. Fill the box, close, and tie with the stamped organdy ribbon.

Project Numbers 73 & 74

Stamps: Seashells, Flower Cluster

Supplies: Wrapping Paper, Black Ink Pad, Colored Markers

Tips & Techniques: Ink the stamp and stamp across the paper randomly or following a grid. (review the section on repeating images). Color in the floral cluster.

Project Number 75

Stamps: Seashells, Sun

Supplies: Organdy Ribbon, White Paper Basket, Black Ink Pad, Brown Brush Marker

Tips & Techniques: Flatten the basket, ink the shell stamp in brown and stamp it in the center, along the bottom, of each of the larger sides. Ink the smaller shells one at a time and stamp them next to the grouped shells. Draw dots around the shells to tie them all together. Stamp the sun in the upper left corner and color in the sun.

Project Number 76

Stamps: Heart & Dot, Single Flower, "Happy Birthday"

Supplies: Card, Black Ink Pad, Black & Green Brush Tip Markers, Black Fine Tip Marker, Colored Markers

Tips & Techniques: To draw the frame, use a ruler and fine tip marker. Draw a line 1/2 inch in from all four sides of the card. Draw another line 1/4 inch inside the first one. In between the two frames draw an even number of lines on each side which will give you an uneven number of boxes. We drew twelve lines on the narrow side and sixteen on the long sides. Starting in a corner, color in every other box in black to form the checkerboard. With the black ink pad, ink the heart and stamp three across the top and the bottom as in the sample. With markers ink the flower in black and the leaves in green and stamp them in between the hearts. Color the hearts and flowers and stamp "Happy Birthday" in the center of the card.

Project Number 77

Stamps: Fleur-de-lis

Supplies: Paper Ribbon, Blue Brush Tip Marker

Tips & Techniques: Ink the fleur-de-lis stamp with the blue brush marker and stamp it randomly on the paper ribbon. Wrap the gift and tie the ribbon into a bow.

Project Number 78

Stamps: Bear, Heart & Dot, "Happy," "Valentines," "Day"

Supplies: Card, Black Brush Marker, Black Ink Pad, Black Fine Tip Marker, Red Brush Marker, Colored Pencils, Colored Markers

Tips & Techniques: Ink the bear stamp in the black ink pad and stamp it on the bottom left corner of the card. Hand draw the thought

bubble above the bear. Using the black brush marker, stamp the heart of the heart & dot stamp inside the thought bubble. With the red brush marker, ink the words "Happy" "Valentines" "Day" and stamp them along the top and down the right side of the card. Add an apostrophe to "Valentines." Color the bear, the bow, and the heart.

PROJECT NUMBER 79

STAMPS: Ivy

SUPPLIES: White Card Stock, Green Brush Marker, Green Organdy Ribbon, X-Acto Knife, Scissors, Pencil

TIPS & TECHNIQUES: Using the template cut out the box. Score and fold as indicated. Using the X-Acto knife, cut slits as indicated on the template. Stamp the ivy stamp inking it with the green brush marker around the box. Close the box and tie with a green ribbon.

PROJECT NUMBER 80

STAMPS: Ivy, "Thank You"

SUPPLIES: Card, Card Stock, Green Brush Marker, Black Ink Pad, Colored Pencils, Pencil, X-Acto Knife

TIPS & TECHNIQUES: Lightly draw a square on the front of your card. Ink the ivy stamp in green and stamp it along the pencil mark. When completed, cut along the inside of the ivy to form a window. Layer colored card stock on the inside of the card and stamp the "Thank You" stamp so you see it through the window.

PROJECT NUMBER 81

STAMPS: Moon & Star, Bird, Basket, Balloons, "Congratulations"

SUPPLIES: Card Stocks, Black Ink Pad, Colored Pencils, Black Brush Marker, Black Fine Tip Marker, X-Acto Knife

TIPS & TECHNIQUES: On a long piece of card ink the basket in the black ink pad and stamp it just below the middle of the card. Ink the moon with the black brush marker and stamp it in the upper right corner. Ink each balloon separately and stamp them as indicated on the example. Draw lines to the basket with the fine line felt pen. Ink the star of the moon & star stamp and stamp it randomly all over the card. With the X-Acto knife, cut a slit in the card at the top of the basket. On a long thin piece of paper, stamp the bird and "Congratulations." Cut around the bird, stopping at the feet. This piece of card stock must fit into the slit cut in the top of the basket. Color everything and glue the outside edges of the card stock to contrasting paper. Be careful not to glue the area which will house the "Congratulations."

PROJECT NUMBER 82

STAMPS: Sunflower, Bow

SUPPLIES: Card Stock, Black Brush Marker, Colored Pencils, Ribbon, Black Fine Tip Marker, 1/8-inch Hole Punch

TIPS & TECHNIQUES: Cut an oval shape out of

card stock to make a gift tag. Ink the flower portion of the sunflower stamp and stamp it near the bottom of the oval. Mask the flower and stamp the bow stamp with one side of the ribbon on each side of the flower. Following the alphabet guide, write the word "To." Punch two holes near the top, pull the ribbon through and tie in a bow. Color in the flower and bow.

PROJECT NUMBER 83

Stamps: Sun, Sunflower, "Happy Birthday," Moon & Star

SUPPLIES: Card, Card Stock, Black Ink Pad, Black Fine Tip Marker, Colored Pencils, Ruler

TIPS & TECHNIQUES: Using the example as a guide, ink and stamp the sunflowers. With the black fine tip marker draw stems from the suns to the bottom of the card. With the black brush marker, ink the leaves of the sunflower stamp and stamp them next to the stems. Also ink the star of the moon & star stamp and stamp it between the sunflowers. Draw stems and leaves to make them star flowers. Color the images and stamp "Happy Birthday" between the flowers. Layer the papers and mount them onto the card.

PROJECT NUMBER 84

STAMPS: Ivy, "Thinking of You"

SUPPLIES: Bookmark, Ribbon, Green Brush Marker, Green Fine Tip Marker

TIPS & TECHNIQUES: With a green brush marker, ink the ivy and stamp it diagonally across the bookmark. Stamp "Thinking of You" alongside the ivy. With the fine tip marker draw dots randomly in and around the ivy. Tie with a pretty ribbon.

PROJECT NUMBER 85

STAMPS: Bird, Bow, Heart & Dot

SUPPLIES: Card Stock, Sticker Paper, Black Ink Pad, Black.Brush Marker, Narrow Ribbon, Colored Pencils

TIPS & TECHNIQUES: Score and fold the card as you see in the sample. This card works well as a self-mailer, with the side pictured as the back and the other side used for the address, etc. Ink, using the black brush marker, the bird without his feet and stamp once in the center of the back flap. In the pad, ink the bow and stamp once on either side of the center bird. Stamp two more birds, one on each side of the bows. Tie a bow on each side of these last birds. Color them in and close with a heart-stamped colored sticker.

PROJECT NUMBER 86

STAMPS: Basket, "Happy Birthday"

SUPPLIES: Card Stock, Black Ink Pad, Ribbon, Colored Pencils, 1/8-inch Hole Punch

TIPS & TECHNIQUES: Ink the basket stamp in the ink pad and alternately stamp it right side up and right side down across the card. Fold

the card so that the back flap extends below the front of the card. Stamp "Happy Birthday" on the top flap. Glue a piece of colored card stock inside the back flap of the card. Color in the baskets and punch a hole in the card for a ribbon.

PROJECT NUMBER 87

STAMPS: Seashells, "Thank You"

SUPPLIES: Card Stock, Black Ink Pad, Colored Pencils

TIPS & TECHNIQUES: Using the black ink pad, stamp the shells and place them in all four corners of the card stock. Stamp "Thank You" in the center. Color the shells with colored pencils.

PROJECT NUMBER 88

STAMPS: Fleur-de-lis, "Congratulations"

SUPPLIES: Card Stock, Pigment Ink, Gold Embossing Powder, Embossing Supplies

TIPS & TECHNIQUES: Stamp the fleur-de-lis, using pigment ink, end to end and then tip to tip across the bottom of the card. Emboss the images in gold. Stamp the "Congratulations," also using pigment ink, in the center of the card and emboss.

PROJECT NUMBER 89

STAMPS: Fleur-de-lis

SUPPLIES: Cloth Napkin, Foam Brush, Fabric Paint

TIPS & TECHNIQUES: Review the section on stamping on fabric and stamp around the edge of the napkin, creating a border.

PROJECT NUMBER 90

STAMPS: Fleur-de-lis

SUPPLIES: Card Stock, Pigment Ink, Gold Embossing Powder, Clear Embossing Pen, Embossing Supplies, Ruler

TIPS & TECHNIQUES: Cut a piece of card stock 2 inches by 8 1/2 inches for the napkin ring. This should be adjusted to accommodate different size napkins. Stamp the fleur-de-lis in the center using pigment ink and emboss in gold. Using a ruler, draw two parallel lines on either side of the fleur-de-lis with an embossing pen and emboss in gold. If you do not have an embossing pen, try using a glue pen. Glue the ends together to form the napkin ring.

PROJECT NUMBER 91

STAMPS: Fleur-de-lis

SUPPLIES: Card Stock, Buff-Colored Mailing Tag, Pigment Ink, Gold Embossing Powder, Embossing Supplies, Black Fine Tip Marker, Ribbon

TIPS & TECHNIQUES: Using pigment ink stamp the fleur-de-lis in the center of a piece of card stock and emboss it in gold. Layer the card stock onto the buff mailing tag. Using the alphabet guide write "To." Use a pretty ribbon to complement the card stock color.

PROJECT NUMBER 92

STAMPS: Fleur-de-lis

SUPPLIES: Place Card, Card Stock, Pigment Ink, Gold Embossing Powder, Embossing Pen or Glue Stick, Embossing Supplies

TIPS & TECHNIQUES: Stamp the fleur-de-lis on the left side of the place card, using pigment ink. Emboss the design in gold. With the card laying flat on a piece of scrap paper, go around the edge with an embossing marker or a glue stick and emboss in gold. Do two sides at a time to make it easier to hold the card while heating it. Place the place card over a piece of slightly larger card stock and glue together.

PROJECT NUMBER 93

STAMPS: Seashells

SUPPLIES: Card Stock, Pigment Ink, Gold Embossing Powder, Embossing Supplies, Embossing Pen, Ruler

TIPS & TECHNIQUES: Using pigment ink, stamp the seashells in the center and emboss in gold. Using the ruler, draw two parallel lines below the shells, using an embossing pen. Emboss the lines in gold.

PROJECT NUMBER 94

STAMPS: Bear

SUPPLIES: Card Stock, Black Ink Pad, Red & Blue Fine Tip Markers, Small Plastic Bag, Colored Pencils or Markers, X-Acto Knife, Ruler

TIPS & TECHNIQUES: Cut a piece of card stock 11 inches by 51/4 inches. Fold in half and then measure in 1 1/2 inches from each end and fold in. These two ends will be glued together to create the base. Open the card stock and using a round template draw a circle and cut it out. Using slightly larger templates and a fine tip marker, draw lines around the cut-out circle to frame. With a black ink pad stamp the bear twice below the circle, positioning the bears so they appear to be holding up a ball of candy. Color in the bears and their bows. Fill a small plastic bag with candy and secure inside the bag with glue. Glue the two bottom pieces together.

PROJECT NUMBER 95

STAMPS: Bear, Bird, Balloons, Sun, Floral Filler, "Happy Birthday"

SUPPLIES: Card, Card Stock, Black, Blue, & Green Brush Markers, Black Ink Pad, Colored Markers, Colored Pencils, String, Glue or Double-Stick Tape

TIPS & TECHNIQUES: Review the section on creating pop-ups. Stamp the bear, in black, on card stock, color, and cut him out. Using the black ink pad, stamp the sun, the birds, and

the balloons (you will need to mask the blue balloon). Using the blue marker, ink and stamp the "Happy Birthday." Stamp the floral filler stamp, in green, several times on the back of the card. Mask below the fold so the flowers appear to be standing up. With the same green marker, ink just one flower of the floral filler and repeatedly stamp it around the card. Color the images. Make a base for the bear and position it in the card. Using a needle and thread, bring a string up from the back, at the base of each balloon, and with the card open glue the strings to the bear's paw. Use a piece of tape to attach the string or thread to the back of the card. Position and glue the card with the pop-up inside a slightly larger colored card. This creates a frame and also covers the thread ends.

PROJECT NUMBER 96

STAMPS: Bear, Heart & Dot, "Thank You"

SUPPLIES: Card, Black Ink Pad, Black & Red Brush Markers, Colored Pencils or Markers

TIPS & TECHNIQUES: Starting in the middle of the card ink and stamp the bear in black. With a black brush marker, ink only the heart of the heart & dot stamp and stamp it right next to each of the bear's paws. Next stamp the bear on either end touching a heart. Using markers, ink the "Thank You" stamp so that the heart is red and the words are black, and stamp it twice.

PROJECT NUMBERS 97 & 99

STAMPS: Balloons, Moon & Star, Bear

SUPPLIES: Card Stock, Black Brush Marker, Black Fine Tip Marker, Black Ink Pad, Colored Pencils and Markers, Ribbon, Decorative Scissors, 1/8-inch Hole Punch

TIPS & TECHNIQUES: Use the template and enlarge it to create hats for the birthday children and teddy. Use the stamp pad to ink teddy. Stamp him so that he appears to be tumbling across the hat. With the marker, ink one balloon at a time and stamp them on both hats. With the fine tip marker, draw strings for the balloons. Make the strings wavy so they appear to be happily flying. Ink the star and star-stream of the moon & star stamp and stamp it several places on both hats. Color in the images and trim the edge with decorative scissors. Punch holes at each end and tie with ribbon to form the hats.

PROJECT NUMBER 98

STAMPS: Bear

SUPPLIES: Place Card, Card Stock, Black Ink Pad, Red & Blue Fine Tip Markers, X-Acto Knife

TIPS & TECHNIQUES: Ink the bear in black and stamp him on the left side of the place card with the ears and top of his head above the center line. With an X-Acto knife, cut from the fold line around the head and ears, stopping at the fold line. Fold the card and the head and ears will pop up. Using the alphabet guide,

write the names of the children on the place cards. Also draw some confetti free-hand around each name (you can use the confetti on the "Congratulations" stamp as a guide). Color the bear.

PROJECT NUMBER 100

STAMPS: Bear, Balloons, Bow

SUPPLIES: Card Stock, Black Ink Pad, Black Brush Markers, Colored Pencils and Markers, Red Fine Tip Marker, Ruler

TIPS & TECHNIQUES: Because we think it's more fun to stamp than to write, we like to have our invitations typed out on the computer. Then we can spend our time stamping and coloring the images. Stamp the bear at the bottom, using the black ink pad. Tilt him so he appears to be dancing. With the brush markers, ink one balloon at a time and stamp each alongside the words. Stamp the bow at the top. Fill in with confetti drawn free-hand, using the confetti on the "Congratulations" stamp as a guide, if you wish. Using the ruler draw two parallel lines at the top and bottom of the card with a red fine tip marker. Draw tails on the balloons making them wavy to indicate they are flying free. Color everything, layer on contrasting paper and mail them out.

NOTE: It's a good idea to find your envelope first and then design your card around the envelope, especially when you are using a square format.